S0-AXP-737

HISTORY ON ART'S SIDE

SOCIAL DYNAMICS IN
ARTISTIC EFFLORESCENCES

HISTORY ON ART'S SIDE

Social Dynamics in Artistic Efflorescences

VYTAUTAS KAVOLIS

DICKINSON COLLEGE

Cornell University Press | ITHACA AND LONDON

First published 1972 by Cornell University Press.
Published in the United Kingdom by Cornell University
Press Ltd., 2–4 Brook Street, London W1Y 1AA.

International Standard Book Number 0-8014-0715-X
Library of Congress Catalog Card Number 70-38683

Printed in the United States of America by Vail-Ballou Press, Inc.

*Librarians: Library of Congress cataloging information
appears on the last page of the book.*

Acknowledgments

For permission to base chapters of this book on several of my articles, I am indebted to the publishers and editors: "Economic Correlates of Artistic Creativity," *American Journal of Sociology*, 70 (November, 1964), 332–341, © by the University of Chicago, by permission of the University of Chicago Press; "Political Dynamics and Artistic Creativity," *Sociology and Social Research*, 49 (July, 1965), 412–424; "Community Dynamics and Artistic Creativity," *American Sociological Review*, 31 (April, 1966), 208–217; "Religious Dynamics and Artistic Creativity," reprinted with permission of the editor, *International Journal of Contemporary Sociology* (previously *Indian Sociological Bulletin*), Vol. 4, No. 2 (January, 1967), 133–145; "Sex Norms, Emotionality, and Artistic Creativity: Psychohistorical Explorations," reprinted from *The Psychoanalytic Review*, Vol. 58, No. 1 (Spring, 1971), 22–36, through the courtesy of the editors and the publisher, National Psychological Association for Psychoanalysis, New York, New York.

I am grateful to Willis H. Truitt for inviting me to lec-

ture at the 1969 Symposium on Aesthetic Values at the University of South Florida—a stimulus for writing Chapters 10 and 11; to Allan I. Ludwig, Herbert Moller, H. Wade Seaford, Philip E. Slater, Ralph L. Slotten, and the readers for Cornell University Press for their critical comments on the manuscript; to Mrs. Isabel Goodhart, who typed it; to students in my seminars on Social Research in the Visual Arts, both at Dickinson College and, in 1971, at the Graduate Faculty of the New School for Social Research, who found productive uses for my hypotheses. Meanwhile, my wife has kept the phase cycle, on another level of analysis, moving.

<div align="right">Vytautas Kavolis</div>

Carlisle, Pennsylvania

Contents

HISTORY ON ART'S SIDE

SOCIAL DYNAMICS IN
ARTISTIC EFFLORESCENCES

And everything that disturbs the mind
without causing it to lose its equilibrium
is a moving means of expressing the innate
pulsations of life.

<div align="right">ANTONIN ARTAUD</div>

1. On Studying Artistic Creativity

Cultural, like economic, goods are not produced in the same amounts or at the same level of quality over long periods of time. In each nation or international civilization, periods of increasing or declining creativity in particular branches of culture may be identified. In the visual arts, the T'ang dynasty in China, the golden age of Athens, and the Italian Renaissance are generally acknowledged to have been eras of creative efflorescence.

The judgments of one age about the artistic creativity of another may be modified by posterity. But, given a sufficiently long time perspective, art historians seem, in most cases, able to arrive at a fairly general consensus as to which periods have reached high levels of artistic attainment.[1] And contemporaries from cultures as diverse as those of the Fiji Islands, Greece, Japan, the United States, and the BaKwele have shown considerable agreement in ranking individual works of art according to merit.[2] Thus there seem to be some universal, cross-culturally valid criteria of artistic quality,[3] though they are not the only criteria used in particular times and places. Members of a

society who have not had the experience of making art (or who respond to other elements in art than the aesthetic) may tend to be more parochial than the artists in their judgments of artistic quality and to regard the familiar or the currently fashionable as the best.[4]

The existence of tendencies toward agreement on artistic quality makes it possible to measure the artistic creativity of particular historical periods by the increases or declines in the quality of art production, on which a consensus of practicing artists and art historians tends eventually to emerge as "historical judgment." Creativity in general can be defined as the production of objects whose design is recognized as possessing some sort of "symbolic validity" in social times and spaces beyond the sociocultural framework in which they have been produced. In this sense, creativity is the production of socially transcendent values —of objects that possess in their structure some sort of capacity to survive repeated cross-cultural and transhistorical re-evaluations (or to recover their vitality after having been pronounced dead). In the case of artistic objects (whether originally intended as "art" or not), this capacity might be called "aesthetic toughness," and objects possessing it could be termed embodiments of "artistic value."

An artistic value can be defined as the expression of a sensibility that, by virtue of the way in which the expressive act is organized, is perceived to be authoritative even by those to whom the sensibility expressed is, in itself, quite alien. In its purest case, artistic value is the formal "compellingness" of a substantively alien perception. Art works whose attractiveness derives solely *from* the expression of a sensibility could have no hold on those whose

sensibilities happen to be different. But the appeal of great art across boundaries of time and culture suggests that the essence of art inheres in a quality that arises *in* the expression of a sensibility but is not identical with the sensibility itself. I conceive of this "transcendent" quality as the authority of a symbolic pattern. In the nonliterary arts, the authority of a form may be spontaneously sensed even when one lacks knowledge of its cognitive content. Our problem is to identify the social conditions under which such forms are most apt to arise.

Can we identify the social conditions that are in fact generally favorable to artistic efflorescences? Do we have enough understanding of civilizational processes to permit projections into the future? Confronted by such questions, the art historian would presumably point, in each historical instance separately, to the gradual growth of a rich *artistic tradition* which, upon attaining maturity, blossoms forth in a cluster of supreme achievements. He is not inclined to make predictions. The historical sociologist, on the other hand, would seek to identify the general type of *social process* which, in all societies with an artistic tradition, produces conditions favorable to artistic creativity. He tests the adequacy of his theories by their predictive capacity.

The two approaches are not mutually exclusive. Indeed, the sociological approach presupposes the existence of a rich artistic tradition and insists only that the full development of such a tradition is stimulated by certain conditions and processes in the social system and retarded by others. Hauser's observation that "artistic excellence . . . is not definable in sociological terms" [5] may be largely correct,

but a good deal of evidence will be cited to support the view that social trends may either stimulate or inhibit qualitative artistic growth.

KROEBER AND SOROKIN

There have been two outstanding earlier attempts to make general statements about the social conditions of artistic creativity on the basis of cross-cultural empirical research. In his theoretical point of view, the anthropologist Alfred Kroeber is not very far removed from the art historian.[6] He explains cultural efflorescences as consequences of a gradual maturation of great symbolic designs. When a cultural design attains maturity, its representatives are most stimulated to fulfill their own individual creative potentials. When whatever a tradition is capable of expressing within its own pattern has been expressed, it ceases to be stimulating, and creativity declines.

The exhaustion of the potentialities of a cultural pattern is, however, inferred from the very fact—the decline of creativity—for which the hypothesis of exhaustion is intended to account. There is no way of demonstrating that the possibilities for creativity which are not being realized do not exist. Paleolithic cave art, which retained its creative vitality within a very limited framework of expressive possibilities for five thousand years, and the "animal style" of the nomadic herdsmen of the Eurasian steppe, which flourished without becoming visibly "exhausted" for three thousand years, indicate that a strong stylistic pattern need not be exhausted—in the sense of being unable to stimulate creativity of the highest quality. The *feeling* that the possibilities of a style (or of a civilization) have become

exhausted is quite another matter from its actual exhaustion. The presence of such feelings may be empirically demonstrable, but they appear to constitute a subjective perception superimposed on the potentialities of development still latent in the style.

Some styles may be inherently more exhaustible than others; solid geometry or nonrepresentational expressionism provide fewer possibilities for formal variation than, for example, a mixed geometric-representational style does. But in most cases it seems impossible to determine what, in a style, is still "unexhausted." To the extent to which it is not the style itself that produces the phenomena of "exhaustion," it must be something in the relationship between style and society. The theory of the exhaustion of pattern is therefore not a very satisfactory explanation of declines of creativity, particularly in the arts. In the sciences, it may hold for the modern period. But in the arts, creativity is exhausted when the stylistic pattern ceases to be adequate to the sociocultural circumstances and the fantasy dispositions they shape, not when it has fulfilled the intrinsic potentialities of which it was capable. (See Chapter 11.)

The evolution of artistic traditions is, for Kroeber, an aspect of a more general process of development of complexly patterned configurations of national cultures. In this process of growth, particular elements of a culture may influence one another—without necessarily, however, advancing or declining together (as is indicated by the lack of consistent correlations between the creative peaks of the arts, religion, philosophy, science, and so on). Kroeber does not go very far, however, in explaining the mecha-

nisms involved in the growth of civilizations—the dynamic agents and motivational factors—nor does he systematically relate cultural growth to specific social processes. His main finding about this relationship is also a negative one: that there is no consistent relationship between the peaks of cultural creativity and those of political power or economic well-being.

Kroeber insists that the rate at which complex culture patterns mature and then are expressed in creative efflorescences has not accelerated within the past twenty-five hundred years. The data on which this somewhat impressionistic conclusion is based are, however, drawn almost exclusively from one structural type of society, preindustrial civilization. Those who argue that an acceleration in the processes of culture growth has taken place draw this conclusion from a comparative study of the cultural traditions of societies at different levels of evolutionary development. Thus the earliest artistic peak on record, in Paleolithic Europe, also lasted the longest, "approximately five thousand years," and was embedded in a single stylistic development, unbroken for twenty thousand years.[7] In the most advanced industrial societies, on the other hand, artistic peaks tend to be of short duration, and stylistic movements almost evanescent.

The sociologist Pitirim Sorokin has identified at least one sociocultural mechanism specifically associated with a peak of artistic attainment.[8] The great amount of quantitative evidence he has collected need not be accepted as an adequately validated set of measures of the behavioral and motivational variables he has been concerned with. But his data suggest a usable hypothesis: that artistic creativity

is enhanced when religious and secular orientations are of approximately equal strength in the mentality of the creative elites (and presumably in the general population, although this is not demonstrated) of a civilization. Such a condition existed in the fifth century B.C. in Greece and the thirteenth to fifteenth centuries in Europe. When there is a radical shift toward the dominance of religious orientations, art declines in favor of religion. An increase in the dominance of secular over religious attitudes causes science to take the lead in cultural development. When an established religious orientation is being challenged by a secular alternative of approximately equal potency or, possibly, when established secularism is being challenged by a potent religious alternative, great art seems most likely to be created.[9] It may be that art is needed in such periods to serve as a psychocultural means for establishing connections between the sacred and the secular—or the "metaphoric" and the "empiricist"—when neither one is sufficiently powerful to suppress the other. A long-enduring balance between such orientations may indeed explain the creative inexhaustibility of the arts of the Paleolithic and the steppe.

Sorokin's general theory of the causes of cultural creativity lists five "basic factors": favorable heredity, the social need for a new system, moderate cross-fertilization, good luck, and cultural (though not necessarily political) freedom.[10] But he has not systematically tested to what extent each of these factors affects cultural creativity in general, nor has he employed them to explain the specific "artistic climaxes" he has identified. Consequently, these factors do not have the status of empirically validated gen-

eralizations. Neither do such additional observations as that economic prosperity is related to creativity in a curvilinear fashion, that "creativity, especially in the religious and ethical fields, increases mainly in periods of catastrophe, or immediately thereafter, including the loss of political independence," [11] and that the "abnormal mobility" during such periods is somehow conducive to creativity.[12] These observations do not add up to an integrated sociological theory, with the intervening mechanisms and the limiting conditions clearly specified. Like Kroeber, Sorokin suffers from the empirically unprovable idea of exhaustion of potentialities.

The essential elements of a sociological theory of creativity are, however, provided by Sorokin, together with much evidence on which such a theory must be based. Perhaps what prevented Sorokin from developing a systematic, empirically based theory of creativity was his increasing tendency to explain social variables by ultimately reducing them to cultural variables. The lack of an adequate psychological theory applicable to historical developments also handicapped him in relating social to cultural dynamics. To be sure, he cannot be blamed for not having a historical psychology at his disposal in 1937— it still has not come into being. Nevertheless, it is on Sorokin's work more than on anyone else's that systematic sociological study of artistic creativity must be founded.

With the important exceptions of Kroeber and Sorokin, neither anthropology nor sociology has addressed itself to a sustained empirical study of the social conditions of artistic creativity. Three more recent approaches can, however, be mentioned. Charles Edward Gray has reanalyzed

the evidence on the cycles of artistic creativity in Western history, but the economic, social, and political cycles to which he related them are purely schematic constructs, vitiated by an arbitrary symmetry of construction.[13] Ronald Jay Silvers, among others, has suggested that cultural creativity, at least in the modern period, is a response to alienation.[14] But this theory has not been empirically tested, nor does it explain why alienation provokes creativity in some cases and not in others. A hypothesis that seems plausible is that an intermediate level of alienation —or perhaps profound alienation combined with an intense feeling of belonging—may be the condition most conducive to creativity. Alvin W. Wolfe has demonstrated a relationship in preliterate societies between art quality and increasing social complexity, as well as the presence of cleavages weakening male solidarity within the community.[15] The applicability of this interpretation to regions of preliterate art other than Africa has been questioned, and it is too simple to account for the variations in creativity over time in complex civilizations.

Most of the analytical frameworks currently accepted in anthropology and sociology are not adequate to deal with the causes of cultural creativity. It is particularly striking that most theories of social change have little relevance to the study of changes over time in the *quality* of cultural attainments.[16] This is partly because recent students of social change have not been much interested in cultural creativity. When they have concerned themselves with symbolic innovations, their theoretical frameworks could generally not help them to distinguish between "significant" and "insignificant" innovations. The conception

of creativity as the bringing about of "valid innovations" is altogether incomprehensible to most social scientists. Extremist doctrines of cultural relativism have limited the capacity of recent anthropology to analyze differences in the qualitative level of cultural, other than scientific-technological, attainments.

It may be possible to relate fluctuations in artistic creativity to certain aspects of social evolution. Since, however, artistic creativity does not, on the whole, show an evolutionary pattern of linear qualitative growth but, rather, a tendency toward cyclical fluctuations, a more promising approach would be to relate it to the theories which conceptualize social processes in terms also of cyclical sequences.

THE PHASE-CYCLE THEORY

My own theoretical approach to artistic creativity has its source in Robert F. Bales's experiments with small groups of students to discover how a group goes about solving a collective problem. On the basis of this work and earlier sociological analyses of cyclical process and tendencies toward equilibrium in the social system, Talcott Parsons and his associates have developed the theory that, in the course of its existence, a social system must cope with four major problems by moving through a sequence of four distinctive phases of a cycle movement.[17] These phases are concerned, respectively, with the adaptation of the system to the conditions set by its external environment, the organization of the system for the effective achievement of its own goals, the integration of this organizational pattern with the emotional needs of the personalities in the system, and the maintenance of some

stable pattern of orientation and behavior during these changes to provide reassurance and the "re-creation" of exhausted energies.

Social systems typically lack the resources for coping with all four systemic problems concurrently. Furthermore, each of the four problems requires for its solution a different psychological attitude in those who have to cope with it. Hence the system tends to move from primary emphasis on one problem to primary concern with another. The sequence in which it typically moves is determined by the "natural" consequences that the solution of one systemic problem has on the system itself. Thus adaptation to a changed environment requires inner reorganization, which in turn poses the problem of relating old emotions to new organizational patterns or, in the case of motivational changes, relating new emotions to old organizational patterns. A direct movement from adaptation to reintegration probably means that the group or society has not effectively reorganized itself in consequence of its changed adaptation to its environment. A failure to attain socioemotional reintegration means that, however well adapted and effectively organized a society is, it continues to produce a high level of subjective dissatisfaction in its members. When the three problems—adaptation, organization, and integration—appear to the members of the society to have been successfully resolved, a "tension-reduction" orientation is spontaneously generated in the social system. Presumably, however, a complete elimination of tensions is possible only when a social system, together with its component personalities, has ceased to exist.

The theory is applicable to whole societies regarded as

social systems and to their distinguishable operational components or subsystems. In its historical application, it avoids most of the criticism that has been directed at earlier theories of periodicities of social change [18] by not conceiving of cycles as deterministic sequences comparable to those of the growth and decline of organisms—inevitable processes, with an immanent goal, which require an exactly definable period to complete themselves and are either unique in the history of a civilization (or of mankind) or else repeat themselves in a highly regular pattern. The phase cycles are, rather, conceived as temporary *trends* which have a certain processual logic of their own once they start, but which are initiated, accelerated, or slowed down and possibly terminated by specific unpredictable historical events, and which are affected, to a considerable extent, by voluntary decisions. While the phases of these cycles must be delineated in some manner to make them usable constructs, they are conceived of as no more than means for identifying the direction of a particular type of social process at a given time and of changes in direction. They are not "natural" entities, but a manner of referring, in the most general way, to the direction and rate of social processes. The historical version of the phase-cycle theory, furthermore, does not assume that at any given time only one phase-cycle process is in operation in a society. Indeed, minor cycles can occur within major cycles of the same type, and a more detailed historical analysis would presumably reveal such cycles within cycles.

In contrast, Sorokin presupposed the operation of a master cycle which, he thought, could account for all essential changes occurring in the sociocultural universe.

Even Kroeber visualized an overall cycle of the growth and dissolution—or ossification—of a "high-value culture pattern," which he treated as the basic determinant of great creative attainments. The assumption of a master cycle is a psychological liability in the empirical investigation of the interaction between different kinds of social and cultural processes; they tend to appear to the investigator as aspects of the master cycle or else as accidental events of no generalizable theoretical significance. The multiple-cycle schema, the paradigm proposed in this book, permits a more differentiated analysis of the processes of sociocultural change. It suggests a general model of the sequence of change, but one that can be applied to each subsystem of the society separately and used to analyze relationships between processes (that is, changes in a particular direction) occurring in different compartments of society and culture.

In my adaptation of the theory to large-scale historical processes, the phase cycle begins, normally, with the *disturbance* of a condition of relative equilibrium—a state which is postulated to exist when the emotions of most active members of a society are congruent with its pattern of organization so that the latter is felt to be "emotionally gratifying." A viable group or society responds to disturbance by intense *goal-oriented* action directed, whether effectively or not, to overcoming the discomfort generated by the disturbance. The action may result in radical changes in the organization of the social system and its functioning or in the personality structures of those involved in it or in both. After a period of intense action, old emotions and new behavior patterns, or vice versa,

have to be mutually *reintegrated*. When a condition perceived as generally satisfactory by those members of the society who can act has been restored, the cycle terminates in a stage of *tension reduction*.[19] In this phase, the group or society is no longer engaged in intensive efforts at solving problems, although, from the point of view of an outside observer, it may still have pressing problems to solve. Its striving toward definite long-range goals and the rate of change of its basic institutions are reduced (on the basis of either satiation or resignation), and the social system tends to become comparatively quiescent. It is not to be assumed that a tension-reduction phase is inevitable. The "natural" development of a cycle may at any point be interrupted by the intrusion of a disturbance which will superimpose a new cycle on the old one. Such disturbances may originate either within the social system or outside of it.

Such cyclical movements occur in all distinguishable subsystems of society—the economy, the political order, the cultural system, and the communal system. These cycles are somewhat independent of each other in their genesis, but they influence each other by their effects, thus distorting the pattern which a particular cycle would assume if it could unfold all by itself, in an artificially purified laboratory setting.

The cyclical movements occurring in the subsystems of the society may be subsumed under an overall cycle affecting the whole society. Thus Black's list of the "critical problems that all modernizing societies must face" suggests a highly simplified phase cycle of modernization that, in our terms, could be described as consisting of the fol-

lowing sequence: (1) disturbance of generalized latency, (2) political-goal attainment, (3) economic-goal attainment, and (4) communal-goal attainment.[20] Advanced industrial societies in America and western Europe may now be entering the fourth stage of the process of modernization, the "postmodern," "postindustrial," "beyond-mass-consumption" stage.[21] In this stage, some of the assumptions governing the earlier stages of modernization are beginning to be questioned, and a new type of community structure—not yet entirely clear in its patterns—may be forming. The increasing primacy, in the imagination of the youth, of moral-emotional over purely political or economic goals is a symptom of this process. According to the theory to be presented, this phase should be generally conducive to artistic creativity—subject to the qualifications indicated in Chapters 6 to 11.

The modernization cycle is, in any particular society, historically unique: it does not repeat itself. The modernization theory, therefore, in some of its formulations, implies a condition of happy stagnancy in societies which have successfully passed through the strains and stresses of modernization. Anthony Wallace's conception of revitalization movements leads to no such expectation. According to this theory, popular movements of ideological and social reconstruction can occur whenever a "steady state" of the social system is disturbed by "increased individual stress" which is eventually perceived as widespread "cultural distortion." Revitalization movements arise as responses to a collective perception that the way of life of one's society has become "distorted" and is no longer emotionally acceptable.[22]

The "steady state" corresponds to our latency phase, "increased individual stress" to the disturbance of latency, and the goal-attainment phase can be viewed as beginning with a permeation throughout the social system of an awareness that the system has become "culturally distorted." Wallace conceives of the next phase, "the period of revitalization" on the assumption that ideological processes have a priority in, and provide the universal key to, the transformation of whole societies faced with widespread internal pathologies. I regard this sequence of phases as one of several possible phase-cycle processes, the relationships among which have to be determined empirically in each historical situation.

Wallace's "period of revitalization" is subdivided into six stages: the formulation of a new code, its communication throughout the society, the organization of an effective movement, its adaptation to other elements of social structure, the cultural transformation of the movement as a consequence of its size and extensive involvements with the rest of the society, and finally, the routinization of the innovations the movement has brought about—whereupon a "new steady state" is established. My integrative stage corresponds best to Wallace's stages of adaptation and cultural transformation; it is in this phase that artistic creativity should reach its peak. While his conception is intended to apply to whole societies and works best when the society is a small one, it corresponds to what I treat as the cycle (potentially repetitive) of ideological action, one of the four types of social-action cycles I distinguish.

The approach in this book is to analyze the phase-cycle processes in each of the subsystems of the society inde-

pendently of processes taking place in the other subsystems, although interconnections are noted and, in Chapter 9, more systematically discussed. In effect, societies in which art has been created are viewed in *their processual aspects only*—with no regard for differences in their organization at any given time—and considered as "products" of *several* different types of historical sequences characterizable, at the most general level of analysis, by the same formal pattern and the same kinds of effects on artistic creativity. The several types of phase-cycle processes are always going on in any society, and much of its character is shaped by the particular coincidence of the various phases of the several cycles it is "experiencing."

The chief advantage of this approach is that it permits the organization of a very large amount of fairly specific historical data from diverse societies into a relatively simple theoretical scheme. The procedure also permits the testing of the logic of the general theoretical scheme in relation to several types of quite distinct social processes and makes it possible to trace the relationships between the cyclical movements occurring in different subsystems of the society and the effects of different kinds of articulation among them.

This then, in briefest outline, is the model of the problem-solving process conceived of as a phase-cycle movement: disturbance of equilibrium, goal-oriented action, social-emotional reintegration, tension reduction. A similar cyclical movement, consisting of the stages of enthusiasm, trouble, stability, and boredom, was earlier postulated by Quincy Wright.[23] The dominant interests corresponding, in his view, to the four phases are religion, politics, eco-

nomics, and art. His cycle is an overall process, affecting a civilization in all of its aspects, and he relates artistic creativity to the stage of boredom. I visualize cycle movements as occurring in each subsystem of the society separately and, in the course of a nation's history, repetitively; my evidence suggests a decline in artistic creativity in the stage of tension reduction, or "boredom" (though a self-conscious cultivation of the aesthetic may indeed become popular in this phase).

The phase-cycle model can be applied to a variety of historical processes. It describes the course of reactions to natural disasters and the trajectory of development of totalitarian societies. It accounts for the very common phenomenon of loss of dynamic impetus by successful social movements—whether religious reformations or secular revolutions, whether labor unions that achieve their most important goals or civilizations that regard themselves as having fulfilled their promise.[24] Upward-mobile family lines and social classes also pass through a similar cycle, frequently terminating in a tension-reduction phase.[25] The successful—as well as the continuously unsuccessful—cease to be effectively competitive, once, or if, they enter into the stage of tension reduction. When a social system most nearly reaches equilibrium, it may be least capable of surviving in a dynamic environment.

In the tension-reduction phase, the *organization* of the social system is likely to differ from its condition during the stage of relative equilibrium with which the sequence started. Change occurs because the effects of the disturbance and responses to it have been incorporated into the structure of the system, possibly transforming it in an

"evolutionary" direction. However, in its *motivational* characteristics the end state is similar to the relatively quiescent condition that was disturbed at the beginning of the cycle. In both cases, the readiness to commit social resources to problem-solving action is likely to be reduced, and a similar, not overly energetic type of personality is likely to be recruited into positions of leadership.[26] Hence, when this state is reached, the "evolutionary" spurt tends to slow down. The phase-cycle model supplements the evolutionary theory of large-scale social change and helps explain the "discontinuous" character of change.[27]

In a complex society, the possibility exists that some social classes or other distinctive groups will be in one phase of a cycle process, and other classes or groups in another phase. While this raises complex problems of historical analysis, the difficulties they present for a study of artistic creativity are reduced by an apparent tendency in the historic civilizations before the Industrial Revolution for the politically or economically dominant classes to exercise an overwhelming influence on the artistic enterprise. Consequently, the phase cycles affecting these classes may, by and large, be regarded as the phase cycles affecting the artistic enterprise. This correlation is attenuated, though probably not eliminated, in advanced industrial societies, especially those of the liberal democratic type, both because of the increasing functional autonomy of the artistic enterprise and because of its orientation to intellectual circles not closely attached to the politically or economically dominant elites. Therefore, the society-wide phase-cycle processes may have a less direct influence on artistic creativity in modern times than they had in historic civili-

zations. The phase-cycle movements affecting particular subgroups within the society—including the alienated and the underprivileged—are probably becoming more important influences on creativity.

I originally hypothesized that artistic creativity tends to be stimulated in the phase of social-emotional integration,[28] and inhibited—though to varying degrees—in the other phases of any type of large-scale process. Chapters 2–5 attempt to test this hypothesis in relation to four analytically distinguishable types of social processes. In Chapters 6–8, the phase-cycle theory, which was originally designed as a conceptualization of cyclical sequences of social action, is applied to historical changes in certain types of motivation apparently relevant to artistic creativity. In the concluding chapters, the theory is consolidated and expanded.

The theory is developed by exploring the relationships between historical variables it has specified as relevant in a wide variety of settings. No claim is made that the evidence cited is sufficient to establish the phase-cycle theory of artistic creativity as empirically verified or that only the processes subsumed under this theory affect variations in societal creativity in visual art. In particular, effects of social structures or of the social organization of the artistic enterprise itself or of favorable and unfavorable social constellations of particular individuals (artists, patrons, dealers, critics) on creativity are not considered.[29] Individual psychological factors also are not discussed. My purpose is to systematize a particular set of hypotheses useful in the study of the complex historical dynamics underlying the varying *capacity of societies* to stimulate creativity in the

visual arts, and to explore a variety of means available for testing these hypotheses in particular situations.

The hypotheses have been developed by interrelating various types of observations, both impressionistic and quantified, from art history, anthropology, cultural sociology, and historical social psychology. But since the dependent variable, artistic creativity, cannot be precisely measured and even the sociological data only hint at the processes by which creativity is influenced, one has to develop theories by continuing in various ways to examine how well they fit with the data and, when the data change, by retesting the theories. The test of the goodness of a theory in this risky area depends on two criteria: whether it explains more than other existing theories do and whether it can generate research that tests the theory and leads beyond it.

The theory is designed as a *partial* explanation of the changes over time in the achievements of any society in the "static" visual arts. It does not deal with the immanent dynamics of style development. Although the theory is not directly concerned with creativity in the arts other than painting, sculpture, graphics, and, to some extent, architecture, its applicability to other arts is not foreclosed. Artistic creativity in preliterate societies is not systematically investigated. Evidence from such societies is cited only for the light it may throw on processes of creativity in the historic civilizations.

I. SOCIAL DYNAMICS

2. Economic-Action Cycles

Studies of the relationship between economic conditions and artistic creativity have usually been based on somewhat imprecise historical data from the urban cultures of classical and modern Europe.[1] They suggest the presence of a direct relationship between economic achievement and artistic creativity.[2] It may be argued, however, that the virtual exclusion of data from preliterate cultures, together with inadequate attention to intervening variables, has frequently resulted in generalizations about the economic backgrounds of artistic creativity which lack both universality and theoretical significance.

An attempt will therefore be made to deal with this relationship in a somewhat wider perspective and to formulate a conception of the mechanisms responsible for the observed associations between economic and artistic conditions. The processes to be related to artistic creativity will be conceptualized within an interpretive framework derived from the sociological theory of the phase cycles.[3] First, however, to demonstrate the need for such a theory, it must be shown that artistic creativity cannot be ex-

plained as a natural product or a symbolic expression of concentrated wealth or of comfortable general prosperity, as some of the existing theories implicitly suggest.

DEGREE OF PROSPERITY

To indicate the dependence of artistic creativity on economic capacity, evidence can be cited to show that an advance in prosperity[4] or the attainment of economic dominance in a culture area[5] is frequently associated with increases in artistic creativity. On the other hand, a long-range decline in economic activity or prosperity appears to be associated with a lowering of artistic creativity.[6]

These data may merely mean, however, that *changes* in economic prosperity are correlated with variations in artistic creativity. While it may be true that "general poverty" is "discouraging to artistic achievement,"[7] no specific level of prosperity of a society as a whole can be identified as necessary for artistic excellence. The cave art of the European Paleolithic hunters, the rock art of South Africa, and the powerful image-making of the Australian natives are all associated with quite limited material resources.[8] "In Oceania . . . life is often very precarious indeed," especially "in the swampy areas of New Guinea or in the very inhospitable coral islands," yet these areas "have yielded some of the finest works in the whole of primitive art."[9]

As Redfield has observed, "Such a contrast as that between the Haida and the Paiute Indians reminds us that generally speaking a people desperately concerned with getting a living cannot develop a rich moral or aesthetic life."[10] This generalization, however, points to the artistically adverse effects, *not* of a low-attainment economy,

but of a nearly total preoccupation with economically instrumental action. Such a preoccupation may be a consequence of a low-attainment economy in areas where access to natural resources was difficult, as in the American plains before the introduction of the horse. But where a low-attainment economy is combined with more easily accessible natural resources, as on the Northwest Coast of America, economic backwardness may coexist with a high level of artistic creativity.[11] At comparable levels of achieved prosperity, a cultural emphasis on the accumulation of wealth is likely to preclude an adequate commitment of social resources to artistic pursuits, as a comparison of the Tchambuli, the artistic headhunters, with the Kapauku, the capitalistic businessmen, of New Guinea suggests.[12] When, however, wealth is valued chiefly for the ostentation it makes possible, as among the Kwakiutl, an accumulation of wealth is likely to increase the demand for art and hence its production.[13]

These comparisons indicate that it is not the level of economic attainment in a society but the proportion of social resources allocated to noninstrumental pursuits that is causally related to artistic creativity. Artistic achievement is not proportional to the amount of a society's wealth, nor is it impossible in the absence of a large economic surplus. Art creation is hence not primarily a symbolic projection of material prosperity, though self-conscious art *collecting* may be.[14]

ECONOMIC ADVANCEMENT

While a static cross-cultural comparison does not indicate that prosperity is a prerequisite of artistic creativity, creativity seems to be stimulated by recently attained great

wealth in a society or one of its segments. The accumulation of urban wealth in Europe, beginning in the eleventh century, was followed in the twelfth and thirteenth centuries—an age of "magnificent prosperity"—by the period of Gothic cathedral-building.[15] The creation of great fortunes in America during the nineteenth century was succeeded in the twentieth by the most important American contributions to visual art.[16]

In general, "the flourishing periods of fine art do not come in the periods when a rising upper class is building up its wealth and power, but afterward."[17] One cause of the linkage between the recent acquisition of wealth and artistic creativity is the leisure which the former makes possible, as in Athens and Florence during their most creative periods. But leisure alone is not enough: An artistic decline in Florence occurred during the period of "serious financial crisis and general stagnation" between 1340 and 1400, and the city recovered both economically and artistically in the fifteenth century.[18] The shift of the center of Italian artistic creativity, in the sixteenth century, from Florence to Rome is chiefly attributable to the economic and political power of the popes.[19] Such occurrences suggest that artistic creativity requires a combination of leisure with economic resources or a sense of efficacy.

In this context, artistic creativity could be regarded as a means of symbolically legitimating recently acquired socioeconomic, as well as political, power. It does not, however, seem justifiable to account for this linkage by assuming that in urban, as contrasted with preliterate, cultures artistic creativity is generally a consequence of the accumulation of wealth and may be regarded as a response to

the demand for luxury goods which great wealth presumably generates (at least in nonpuritanic cultures).

In some cases, "refined luxury" indeed coincides with "creative spontaneity" in the arts, as in the Warring States and in the late Shang periods of Chinese history.[20] At other times, by stimulating a demand for luxury goods, great wealth merely increases the capacity to afford, but not the ability to create, works of artistic value.

> The four centuries of the Han *Pax Sinica,* like the four centuries of the Mediterranean *Pax Romana* . . . encouraged the development of a rich material civilization. In both cases the period of creative spontaneity—in the Mediterranean world the apogee of Athens and Alexandria, in China the "Warring States"—had ended. Civilization passed through a stagnant and apparently happy period in which the luxury arts, on both sides, played a considerable role.[21]

It is questionable, however, whether luxury has a creativity-depressing effect all by itself. As is suggested in Chapter 3, political quiescence may have contributed to the decline in creativity in these periods.

A comparison of the effects of recently attained prosperity and of stabilized great wealth on artistic creativity indicates that artistic efflorescences are indeed, to a significant degree, the result of a spontaneous recommitment of social resources from instrumental to expressive pursuits, which the achievement of what is felt to be relative prosperity makes psychologically possible. Social resources may be committed to expressive action, as in Melanesia, where economic achievement is low, provided that, within the context of the prevalent cultural aspirations, it is felt to

be relatively satisfying.[22] In more dynamic economies the successful accomplishment of a significant economic advance apparently makes the diversion of social resources to artistic creativity more probable. But it seems to be in the earlier and less "luxurious" stages of such a diversion that artistic creativity is most stimulated. To explain the frequently evident reduction in artistic creativity in the later stages of economic advancement (which are marked by greater "luxury"),[23] a socioeconomic phase cycle may be conceptualized.

SOCIOECONOMIC CYCLES

The cycle begins when a state of relative economic latency, characterized by what is felt to be a satisfactory adjustment to the environment and by low rates of change, is disturbed by the beginning of a basic economic transformation. There are indications that such periods have a stimulating effect on the visual arts. Walt Rostow has placed the dates of the "take-offs" to industrialization from 1783 to 1802 in Great Britain, from 1830 to 1860 in France, from 1834 to 1860 in the United States, from 1850 to 1873 in Germany, and from 1890 to 1914 in Russia.[24] In four cases out of five, the beginnings of modern artistic efflorescences followed closely upon the take-off. In France, the "great decade" of impressionism, which originated in the 1860's, was from 1870 to 1880. It occurred during a period of economic slowing down, 1873 to 1895.[25] In America, Homer, Ryder, and Eakins, as well as Whistler and Sargent, grew up during the take-off. In Britain, the "generation of 1775" (the approximate birth date of Turner, Girtin, Constable, Cotman, and Crome)

grew up during the take-off period. The only essential contributions of Russia to modern visual art were all made in the first two decades of the twentieth century, though some of them were subsequently further developed by expatriated artists (Kandinsky, Chagall, and the constructivists) in the West.[26] In Germany, the really significant artistic development, expressionism, occurred after the beginning of the twentieth century, in what may be regarded as the phase of integrative reaction after economic-goal attainment. The lack of an artistically stimulating effect of the take-off in Germany may have been due to the intense preoccupation with political organization during the take-off period.[27]

Our theory predicts that the goal-attainment phase, in this case the period of the industrialization process during which economic growth proceeds at the most rapid rate, should be marked by reduced artistic creativity. Such periods were those from 1819 to 1848 in Great Britain, from 1868 to 1893 in the United States, and from 1928 to 1940 in Russia.[28] Few monumental figures in the visual arts have grown up during these periods. In Britain, the generation of 1775 continued its work, the Pre-Raphaelite Brotherhood was founded in 1848 and had fewer major achievements to its credit. The generations that grew up during the maximum-growth phase were responsible for the decline in artistic creativity in the second half of the nineteenth century. The decline may also have been due, however, to ideological and communal latency, as well as to the tension-reductive psychological characteristics of the period. (See Chapters 4, 5, 7, and 8.) In the United States, the situation is comparable in that fewer and less signifi-

cant new figures matured during the maximum-growth period. However, in American society there was no obvious decline in creativity after the maximum-growth period. On one hand, there was a lower peak to decline from than in Great Britain; on the other hand, the America of the turn of the century was in a dynamic stage of the communal cycle, which may have increased the need for art. Nevertheless, the generation that grew up during the maximum-growth period was not responsible for a *major* artistic efflorescence in the United States. In Russia, the rapid-growth period was artistically barren, but more for political than for economic reasons. So was the period that followed—the 1940's through the 1960's.

In principle, the economic reorganization resulting from the Industrial Revolution and its possibly transitional antiartistic effects, both in the West and in the developing non-Western societies,[29] was a process comparable to the economic reorganization which must have occurred in Stone Age Europe when the great tradition of Paleolithic art came to its close in response to the need to adjust to the postglacial environment.[30] In both periods, a radical movement into the goal-attainment phase of the socioeconomic process seems to have diverted attention from artistic creativity.

A second, and major, revival of artistic creativity should follow the transition from the goal-attainment to the integrative phase of the socioeconomic process. Two sets of indicators will be used for identifying such transitions: (1) the beginning of a contraction in the area, value, or amount of foreign trade [31] and (2) the beginning of a long-range decline either in the number of scientific discoveries

(in the case of Greece and Rome) or (in all other cases) in the percentage of the total number of historically important inventions and discoveries made in a particular nation.[32] The latter index is only a tangential indicator of the degree of commitment of social resources to economically relevant activity, and consequently, so far as the present theory is concerned, it should be a less precise predictor of periods of artistic creativity.

On the assumption that artistic creativity is maximally stimulated in the phase of integration following intensive action, *before* the integrative phase passes into that of social latency, it is hypothesized, for the purpose of facilitating measurement, that the maxima of artistic creativity will occur within one hundred years after the beginning of a long-range decline in the commitment of social resources to economic action, as defined by the two previously cited indexes. The first set of data gives the following *predicted* maxima of artistic creativity: Greece, 550–450 B.C.; Spain, 1560–1660; and England, 1634–1734. The second set gives the following maxima: Greece, 300–200 B.C.; Rome, A.D. 100–200; Spain, 1450–1550; Germany, 1100–1200, 1525–1625, and 1875–1975; France, 1200–1300 and 1825–1925; Italy, 1350–1450; Holland, 1551–1651 (or 1675–1775); [33] and England, 1100–1200 (or 1250–1350), and 1800–1900.

To provide a rough test of this hypothesis, the "artistic climaxes" of the respective nations, as judged by Sorokin, will be listed.[34] The list which follows combines his separately identified peaks in the creation of sculpture and of painting for each nation, and, in parentheses, contains modifications suggested by current art-historical judgment. Accordingly, the following appear to be periods of artistic

efflorescence: Greece, 559–300 B.C.; Rome, 30 B.C.–A.D. 110; Germany, 1120–1260, 1400–1560, and 1800–1900 (1900–1930); France, 1140–1325, 1450–1550(?), 1620–1670(?), and 1760–1910 (1820–1930); Italy, 1420–1600 (1680); [35] England, 1220–1250 and 1715–1850.[36] The period of greatest artistic creativity in Holland and Spain may be set at approximately 1580–1660.

There are artistic peaks which do not seem, at least in this rough comparison, to be associated with the economic variables used here. The French climaxes of 1450–1550, in sculpture, and 1620–1670, in painting, cannot at all be explained by economic phase cycles measured in the present manner. The Roman and the German (1400–1560) artistic peaks occurred a little earlier than predicted, and the Italian and Spanish peaks a little later. But, with the two French exceptions, artistic efflorescences occurred approximately at the theoretically predicted periods. Furthermore, both French cases are open to question. The main reason for the peak of 1620–1670 was that artists of French birth, Nicolas Poussin and Claude Lorrain, neither of whom derived his style from the French tradition, were *working in Rome*. Insofar as their work was influenced by sociological factors, it might have been as much a response to the Roman as to the French historical situation. And there does not seem a firm enough basis in the records of art history to substantiate Sorokin's judgment that 1450–1550 in France represents a major peak in the production of sculpture. (Some of the most significant artistic creativity of this period was localized in Burgundy, which, in the fifteenth century, would have been grouped with Flanders rather than considered part of France.) Thus

neither of the two cases provides unambiguous evidence against the economic-cycle theory of artistic creativity.

There is apparently a tendency for periods of incipient decline in the commitment of social resources to economic action to coincide or overlap with significant artistic efflorescences. This correspondence is the more remarkable in view of the imprecision of the data, which were not collected for the purpose at hand. As was expected, the first index seems to be a somewhat better predictor of artistic peaks, except in the case of England, where the Puritan Revolution may have "postponed" an otherwise expectable artistic efflorescence (although even in this case an artistic peak overlaps with the predicted period).[37] Efflorescences of art seem to be products of the generations of artists who have grown up *after* the periods of most intense economic action in their societies. Perhaps creative artists must not only live in a society which is beginning to be less concerned with economic-goal attainment, but they must also have grown up in such a society and have had their personalities shaped by it.

Whether any of the modern economic systems of the West has passed from the goal-attainment to the integrative phase is debatable. One would expect the most advanced industrial economy to be most likely to have made this transition. Various kinds of evidence suggest that the American economy has indeed entered the integrative phase: the continuous decline in the per capita rate of new industrial patents since 1910, and precipitously so since 1930; [38] the shift of attention from work to leisure and from the leaders of production to the leaders of consumption; [39] the cult of togetherness among corporation men; [40]

the discovery by business leaders of their "concern for the public welfare"; [41] the increasing disinclination of college graduates to choose business careers. The American economy has basically solved the problem of production; it is confronted with the problem of the social uses of its products (actual and potential).[42] This is an integrative problem. If the American economy is in fact in the integrative phase, it may have helped to bring about the artistic efflorescence identifiable with America's most notable contribution to the visual arts—abstract expressionism.

The hypothesis that artistic creativity is associated with the passage from the goal-attainment to the integrative phase may be supported also by prehistoric data. The important artistic tradition of the European Paleolithic hunters appears to have been created by an "advanced hunter culture" which had reached a "dead end along a particular path of development," while "two other types of economic activity, hoeing of the soil and pasturing cattle, . . . in combination led to settled agriculture," without producing, during the Paleolithic period, art of comparable value.[43] It was the materially adequate [44] yet no longer progressing hunter culture that was responsible for "the birth of art." [45] A parallel association of relative economic backwardness with artistic creativity was a factor in the production of the rock engravings so profusely carved, in several areas, in the period of transition from the Stone to the Metal Age.[46]

If other variables are at all comparable, the lack of economic progress in one society while other societies in similar circumstances are advancing implies relative satisfaction with the level that has been attained. This suggests an

orientation to the integrative exigencies in the social system on the part of the Stone Age hunters who created the greatest art of their age. It is, however, impossible to distinguish the integrative from the latency stage on the basis of prehistoric materials.

Presumably, no industrial economy as a whole has yet passed into the stage of tension reduction. Such a passage would seem possible only if complete automation and approximate equality in the distribution of wealth were achieved.[47] However, it seems empirically justifiable to locate the Italian economy of the seventeenth and eighteenth centuries in that phase of an earlier cycle of economic growth, based on international trade rather than industrial production.[48] By the seventeenth century the Italian economy had been in a state of prosperous stagnation for a long enough period for us to assume that it had entered the tension-reduction phase. What followed—after the "general collapse of the Italian economy which reached its climax in the middle of the [seventeenth] century" [49]—was a period of artistic decline.

To summarize: It can be said that artistic creativity tends to be stimulated in the period of initial response to the beginning of economic transformations and in the phase of social-emotional reintegration following successful intensive action in the economic sphere. It is adversely affected in the phase of the most intensive action in the economy and in the phase of economic latency—which has been here identified as the condition of relative equilibrium preceding the beginning of a basic transformation of the socioeconomic system.

Clearly, artistic creativity does not develop from a state

of relatively stable social integration, but from a felt need to achieve reintegration. Objectively viewed, the need exists during all stages of an economic transition, but the requisite social resources are available only in its very early stages (when they are not yet primarily committed to economic action) and in its relatively late stages (when the results of economic action are felt to be sufficiently satisfying to justify releasing more resources for symbolically expressive activities,[50] but before the need for reintegration is felt to have been adequately met).

CONCLUSION

The data suggest that an important causal agent in artistic efflorescences is a widely felt need for reintegration of the social system. The collective—though not necessarily conscious—perception of this need is viewed as the cause of an increased demand for art and consequently of a tendency to commit social resources to the processes of artistic creation. It is not assumed, however, that the social demand for art develops only from the integrative need. Furthermore, the allocation of social resources to artistic creation does not seem sufficient by itself to sustain a high level of artistic achievement, if the integrative need in the social system—hence the social utility of art as an integrative factor—has significantly declined.

Regarded by itself, no economic or other social process—such as those analyzed in Chapters 3, 4, and 5—can be expected always to have the theoretically predicted effect on artistic creativity. First, a tradition of high art must be present for any social factor to have a significant artistically stimulating effect, and the existence of such traditions

cannot be taken for granted. Second, the artistically propitious phases of one type of cycle may overlap with, and in their effects be offset by, unfavorable phases of other partly differentiated cycles (political, religious, communal), or vice versa. Third, any cyclical movement may be interrupted by the beginning of a new cycle before the former has reached the integrative phase, in which its artistic effects should be most strongly felt.

3. Political-Action Cycles

It seems reasonable to expect artistic creativity to be related to sociopolitical processes in the same way as it has been found to be associated with socioeconomic ones: in both cases, creativity is stimulated by initial disturbance of a relative equilibrium, reduced by goal-oriented action, increased in the integrative phase, and inhibited in that of latency. The pattern may, however, be subject to modifications resulting from the differences between economic and political processes. These theoretical expectations will now be tested in relation to two types of sociopolitical processes, warfare and state consolidation.

WARFARE AND ARTISTIC CREATIVITY

One type of political process that requires the maximum commitment of resources to goal-directed action is warfare. A correlation between periods of warfare and those of artistic creativity has been noted, mostly in Asian civilizations, by Mukerjee [1] and, in Europe, by Sorokin.[2] When, however, a more exact historical analysis is possible, it suggests that artistic creativity is maximized not during, but

immediately after, the periods of most intensive political action,[3] during the integrative phase of this type of sociopolitical process.

The seventeenth-century efflorescence of Dutch art may be regarded as a paradigmatic case. "Most of the artists of the seventeenth century were born when Holland was at war with Spain and fighting for her very existence."[4] The peak of creativity followed the conclusion of the truce of 1609, by which the Netherlands achieved recognition of its national independence.[5] But the "births of superior talent ceased at 1640."[6] And, as Holland began to decline as a world power, "late in the seventeenth century Dutch painting once again became susceptible to French influence."[7]

Instances of gratifying victories in war that were followed by artistic revivals, particularly in monumental art (which has frequently been sustained by an economic exploitation of the vanquished), can be cited almost at random. The "booty of war" repeatedly nourished Egyptian creativity.[8] Assyrian sculpture "followed the fortunes of the empire."[9] The golden age of Athens was initiated by the victory of 480 B.C. The early success of the Crusades was followed by the age of cathedral building, from approximately 1100 to 1270.[10] In Renaissance Italy, local victories were celebrated by the creation of great works of art. (However, the creativity of the Renaissance was sustained without any great national victories by Italians over non-Italians.) In France and Spain, periods of military glory preceded those of artistic renown.[11] The United States attained world leadership in painting, for the first time, after its victory in World War II. Presumably, vic-

tory in warfare facilitates artistic creativity by releasing social resources, including those gained by conquest, from political to other kinds of action. However, resources so released are channelized to artistic creativity only to the degree to which art is culturally valued. Military victories did not stimulate artistic creativity in Sparta. But neither did they in the Soviet Union, although art has been highly valued and richly supported in the period since the victory over Nazi Germany. Perhaps the "hard," discipline-laden politico-ideological orientation of both these societies prevented their military victories from contributing to artistic creativity. The artistically stimulating effects of victories in war seem, in any case, to have been stronger in ancient monarchies than they have been in modern national societies.

As might be expected, a radical defeat, particularly if it entails a collapse of the political order or prolonged occupation by a foreign power or severe economic impoverishment, has frequently led either to the destruction of a civilization or an immediate decline in artistic excellence (which has sometimes been followed by a revival of creativity after the conquerors have amalgamated with the conquered).[12] Defeat by invading peoples was followed by destruction of the Assyrian, Minoan, Mycenaean, Phrygian, Sassanian, and ancient American civilizations.[13] Artistic decline set in after the collapse of the Old Kingdom of Egypt; the Athenian defeat during the Peloponnesian wars; the conquest of Ceylon by Rājarāja in the eleventh century and the Indian invasion of 1213; the Norman invasions of the ninth century, which ended the Carolingian renaissance; the Mongol invasions of the Near East in the

thirteenth century; and the two conquests of Constantinople, in 1204 and 1453.[14] "The poverty of [South American tribal] art can perhaps be attributed to the decadence that rapidly overtook the tribes which had suffered, directly or indirectly, the effects of European conquest; the slave trade and disease decimated once prosperous and powerful communities." [15] One reason why radical defeats have a destructive or depressive effect on the visual arts is that social resources cannot usually be made available after such defeats for cultural activities in the defeated society. The resources have either been destroyed and expropriated by the victors or they must be devoted to *social* reconstruction. High art cannot be created, because of a lack of resources.

A number of cases suggest, however, that artistic creativity may be stimulated by a moderate defeat, which is neither completely disruptive of the social system nor associated with permanent occupation by an invading power or with general impoverishment. This tendency, if such it is, seems to be particularly characteristic of the modern period. It occurs when ancient nations with well-developed artistic traditions are "shocked into awareness" by defeat at the hands of their more modernized enemies—provided that the reaction to the shock does not take the form of a long-term militaristic mobilization of the society. The defeat of the Armada in 1588 preceded the peak of Spanish artistic creativity, 1580–1660; and Spain's defeat by Napoleon seems to have contributed to the creative growth of Goya. In France, the postdefeat "decade 1870–1880 is by far [the] best period" of the impressionists.[16] The shock of defeat in the Russo-Japanese war of 1904–

1905 may have had an emancipating effect on artistic developments in Russia after 1907, the only period in modern times in which Russian painting had a pioneering significance.[17] The Russian movement was a part of the general European efflorescence then going on, but the political processes affecting Russia may have contributed to the radical vigor with which Russian artists were participating in it.

To account for such cases, it is suggested that a moderately disruptive defeat may have an artistically stimulating effect in a mature civilization by upsetting a previous state of political latency. Insofar as a disturbance of latency increases the felt need for reintegration, it should increase the importance of art for society, as one source of the symbolic means by which the effects of recent disturbances can be articulated into the social-emotional structure of the society. The increased social utility of art should imbue creators of art with a stronger sense of seriousness of purpose, with a greater urgency, and thus make for higher artistic achievements, *if* resources can be made available for artistic activity (as they are unlikely to be in a radically defeated society).

When a disturbance of political latency becomes a continuous condition affecting the social order with great intensity, in what may be regarded as a prolonged goal-attainment phase, it tends to have an adverse effect on artistic creativity. Prolonged periods of unsatisfying warfare—of "wars more exhausting than remunerative, and leading from dominance to stalemate," as Kroeber characterized the military enterprises of Louis XIV [18]—may not permit sufficient allocation of social resources to the

creation of art. "Such conflicts as the Hundred Years' War in France and the Thirty Years' War in Germany produced general misery and retardation of artistic development." [19] The destructiveness of such wars may, however, also have the effect of emancipating the *style* of art from its bondage to established tradition.[20] The critical question is whether social resources and a type of motivation needed to sustain creative attainments will be available for art to benefit from such "liberation" of the creative impulse. Internal wars may similarly affect artistic creativity (Chapter 5).

In periods of prolonged peacefulness, the political system is likely to move toward latency, which should have an artistically inhibiting effect. It is possible to construct an approximation to a quantitative test of this hypothesis. For purposes of measurement, "prolonged peacefulness" is defined as a period of at least a hundred years' duration, during which warfare is less intensively waged than it was either before or afterward. Two of Sorokin's indices of the intensity of warfare will be used: (1) the estimated number of casualties and (2) the duration of warfare.[21] In the following discussion, data are presented on the only periods of history referred to in Sorokin's tables which both indices identify as times of prolonged peacefulness, in the above sense.

In Greece, a decline in warfare occurred during the third and, particularly, the second centuries B.C. Toward the end of this period, a reduction in artistic creativity was evident in mainland Greece and, somewhat later, in the Greek-speaking eastern Mediterranean area as a whole. In Rome, warfare declined in the first and second centuries A.D. A reduction in artistic creativity began in the

second half of this period, when "after a century and a half of imperial peace the mind of the Empire had sunk into an appalling sterility." [22] Rome in the second century A.D. seems, like Italy in the fifteenth, to have been in the integrative phase of an *economic* cycle.[23] This comparison suggests that economic dynamics (Chapter 2) are insufficient to account for artistic creativity.

In Spain, a long-range decrease in warfare began in 1651 or 1676 (depending on which index is used) and continued until the Napoleonic wars. Then, until the twentieth century, Spain was relatively peaceful. This whole period was marked by reduced artistic creativity. The only significant exception is Goya, whose best period was that of the Napoleonic Wars. In Holland, a long-range reduction in warfare started sometime between 1651 and 1726.[24] About 1680, artistic creativity also began to decline. In Austria-Hungary, an era of prolonged peacefulness lasted from 1750 (or 1776) to 1914. This period, particularly the nineteenth century, conforms to the period of expectation of reduced creativity in the visual arts. Whenever the two indices of warfare are in agreement, the periods of prolonged peacefulness are associated with reductions in artistic achievement. The periods of prolonged peacefulness have, however, most often coincided with those of economic stagnation, and the adverse effects on creativity may be a joint consequence of tension-reduction phases in both the economic and political systems. Prolonged peacefulness may, then, be insufficient by itself to put creative energies to sleep.

Matthew Melko's research on peaceful societies casts further doubt on the assumption that peacefulness by itself

inhibits artistic creativity. While by no means all the peaceful periods he has identified are marked by major artistic accomplishments, a great many artistic peaks—the New Kingdom in Egypt, the T'ang period in China, the ninth-to-tenth-century efflorescence in Byzantium, the Athenian, Roman, and Mughal climaxes—were located in periods in which these societies were not fighting any wars on their own territories. (An era without such a war is Melko's operational definition, different from Sorokin's, of a "peaceful period.") Indeed, the only times in which artistic declines occurred in what Melko defines as peaceful periods were in Italy, from 1538 to 1701 (a dubious case, since the decline started late in this period and was greater in the more pugnacious eighteenth century); in Holland, from 1794 to 1940 (another dubious case, since the decline in art started far in advance of approaching peacefulness); and in the Habsburg empire, from 1711 to 1848.[25] Thus it seems justifiable to conclude somewhat cautiously that while postwar integration tends to stimulate artistic creativity, prolonged peacefulness does not necessarily inhibit it.

POLITICAL CONSOLIDATION AND ARTISTIC CREATIVITY

The basic problem in the goal-attainment phase is to achieve "control over parts of the situation in the performance of goal-oriented tasks." [26] This analytical phase can be empirically located within the political process, most obviously, in periods of state organization. Such periods, except for qualifications to be noted, tend to be followed by artistic efflorescences of varying magnitude.

Illustrative cases include the unification of Sumeria by

the third Ur dynasty; the "burst into vivid life" of Chinese painting during the Han dynasty, after the consolidation of the Ch'in empire in 221 B.C.; a second outburst of creativity following the consolidation under the T'ang dynasty, 618–907; and a third, following the Sung reunification in 960. Other examples are the artistic revivals consequent upon the emergence of national dynasties in Ceylon in 150 B.C. and A.D. 1153, in Gupta India in A.D. 320, and in Safavid Persia; the Frankish and Saxon consolidations antecedent to the Carolingian renaissance and the Othonian efflorescence; and the centralization effected by the Macedonian dynasty (867–1056), which stimulated the late blossoming of Byzantine art during the eleventh and twelfth centuries. The establishment of effective feudal orders was followed by artistic efflorescences in Chou China (ninth to seventh centuries B.C.), in thirteenth-century Europe, and in fifteenth-century Japan.[27] "Around 1550 or 1600 . . . the other west-European countries drew abreast of Italy in . . . the arts, and the sciences, after having consolidated themselves into organized nation-states." [28] The consolidation of the Mughal empire in the sixteenth century immediately preceded an artistic efflorescence.[29] The artistic aftereffects of the establishment of Holland as an independent state have been noted above.

The large-scale cycle initiated by a ground-breaking event of political organization may require, in a complex historical constellation, a century or more for its artistic effects to be fully felt. Two centuries elapsed between the conquest of Persia by the Mongols in the thirteenth century and the fifteenth-century artistic flowering under the Timurid princes. Approximately a century passed between

the importation into England of the Norman tradition of miniature painting, after the conquest of 1066, and the remarkable achievements of English pictorial art during the twelfth century; [30] between the final unification of Spain, 1469–1492, and the greatest period of Spanish painting, 1580–1660; and between the establishment of the Latin-American republics and the first significant developments in their art, after 1910. The length of time required to reach the integrative phase of the long-range cycle initiated by state-founding action, a complete absence of such a phase before the beginning of another cycle of intense political action, or possibly the lack of a developed native tradition of high art may explain the several cases (Mongol, Turk, Lithuanian) in which imperial consolidation has not significantly invigorated artistic creativity. [31]

Inconsistently, "the simultaneous appearance of 'empires' after 1300, both in Mesoamerica and in the central Andes," [32] seems to have been associated with a decline in artistic creativity in the Inca empire [33] and an increase in the Mexico of the Aztecs. [34] The Inca decline may in part be accounted for by a continued extremely great commitment of social resources to political and economic action. [35] The degeneration of art in the Soviet Union and Nazi Germany may be explainable *in part* by the same general principle as the decline in the Inca empire. The Aztecs, after the establishment of their hegemony, may have had an integrative orientation like that of thirteenth-century France and fifteenth-century Italy, in contrast to the goal-attainment emphasis characteristic of the Inca as well as of the modern totalitarian states. [36]

The difference between Inca and Aztec religious orien-

tations may also have been to some degree responsible for the different effect of imperial consolidation on artistic creativity. Roger Fry explains the "fantastic inventiveness" of both Aztec and Gothic art as possibly resulting from "the tension of spirit produced by [the] perpetual terror of supernatural forces," which, he thinks, may have had a "stimulating effect on their creative power." [37] The Inca, "a pragmatic people"—like the Romans—appear to have had a more craftsman-like approach to art than the Aztecs had.[38] It is demonstrated in Chapter 7 that religious tensions tend to contribute to artistic creativity.

A strategic Chinese case indicates that, in dealing with historical as contrasted with small-group processes, a consideration of cultural programs must be included in applications of the phase-cycle theory to make valid analyses possible. After the expulsion of the Mongols in 1368, "the new Chinese dynasty of Ming did its best in every sphere of activity to restore its past . . . and to resume history from the point it had reached . . . in 907"; [39] it "decided to take as [its] models the T'ang, who before [it] had been the last sovereigns of a united China." A national consolidation on the basis of such a reactionary program did not invigorate the arts, and a "decadence of sculpture" set in.[40] To provide adequate stimulation for the creation of art, a political consolidation may have to permit considerable scope for innovative cultural expression. A cultural program that is too rigidly forward-looking may have the same inhibiting effect on artistic creativity as a reactionary program.

Cases may be cited in which the opposite of political consolidation—a process of state disintegration—appears

to have contributed to a decline in artistic creativity. The "finest era" of Chinese art ended when "a rebellion of An Lu-Shan" so weakened the empire that "effective centralized control of administration could never be fully restored." [41] In Japan, the great period of Amidist art ended at the beginning of the civil war between the clans of Taira and Minamoto, in the middle of the twelfth century. In Africa, "too often material insecurity, fear of plunder or the raids of slave hunters have, by provoking the disintegration of the society, also killed the art of the people." [42] Such an effect seems particularly likely when disintegration results in continuous instability and impoverishment, rather than in the division of an empire into smaller but viable states.

The dividing of an empire may be artistically inspiring. The "turmoil" of the Five Dynasties period, 907–960, did not prevent a "full flowering of Chinese landscape painting." A suggested explanation is that "the division of the country prevented the expression of . . . energy through normal political channels. [Artistically cultivated] men, who would normally have devoted themselves to the service of the country, found themselves unemployed and turned to the arts." [43] This type of response to the deprivation of opportunity for political action would not be possible, because of a lack of technical competence in the creation of visual art, for the political elites of almost any other society. Furthermore, it presupposes that the economic situation is not wholly desperate.

After the division of China caused by the Manchurian invasion of the twelfth century, "the Sung empire, henceforth restricted to South China (1127–1276), very rapidly

recovered its prosperity . . . and Hangchow, the new imperial capital, . . . during the last quarter of the twelfth century, . . . produced the greatest Chinese landscapists of all time." [44] In this case, a reconsolidation of fragments of the state after partition was combined with economic prosperity. The disintegration of the state was not total and did not preclude a sizable allocation of social resources to artistically creative action, while the disturbance of political latency may have increased the need for art as an integrative factor. All of this occurred in a culture with a highly developed native artistic tradition. The breakdown of imperial control did not destroy the tradition but weakened its restrictive hold on the imagination of the artists, thus releasing their originality.

The fall of Rome had somewhat similar effects on the "provincial" arts of Europe (e.g., Spain). And the weakening of the political authority of the Kievan Rus, in the thirteenth and fourteenth centuries, may have encouraged "the extraordinary development of icon painting and veneration" during this period. "The omnipresent holy pictures provided an image of higher authority that helped compensate for the diminished stature of temporal rulers." [45] (The need for such compensation may be one reason for the association, noted above, between moderate defeats and artistic creativity.) It is significant, however, that while imperial consolidations frequently encourage developments in monumental art (which is used to celebrate the newly acquired grandeur of the state), in the two Chinese cases, as well as in most of Europe during the "Dark Ages," it was principally the production of small-scale art forms that was stimulated.

That large political units are not essential for sustaining artistic creativity at the highest level is indicated by both classical Greece and Renaissance Italy. Expanding empires, like expanding economies, are likely to absorb the energies and deepest interests of potentially creative people in the solution of the complex problems of their administration.[46] But at least imagination is apt to be challenged in periods of expansion. The apparently unshakable weight of an established imperial monolith, on the other hand, tends to force the artist into the mold of a functionary, whom only power fascinates; and "under the highly stabilized and organized states the artist finds but little outlet for the expression of his sensibility. Those works of Mesopotamian art wherein we found most sensibility belong to the early period before a single imperial power had laid its heavy hand on the artist." [47] Prolonged periods of stable imperial dominance, such as "the four centuries of the Han *Pax Sinica*" or "the four centuries of the Mediterranean *Pax Romana*," have tended to reduce "creative spontaneity" in the arts.[48] (These were also periods of luxury, which is discussed in Chapter 2 as a possibly adverse influence on creativity.) Such periods may in part be identified with the latency phase of the sociopolitical cycle that begins with imperial consolidation.

The boredom of "well governed and well administered people"—as well as of prolonged peaceful periods—may represent another variant of political latency.[49] Paradoxically, ineffective government may, as an internal mechanism of disturbing equilibria in the social system, prove to be culturally stimulating.

THEORETICAL INTERPRETATION

Artistic creativity tends to increase in periods following those of intensive goal-oriented action (warfare or political consolidations) in the political sphere. This tendency may be theoretically accounted for by the increased salience of the integrative problem in such periods. A highly salient integrative problem is assumed to increase the social utility of art—the degree to which art can contribute positively to the maintenance and further development of the social system.

When the integrative phase of the sociopolitical process is greatly prolonged, it apparently tends, in the relative absence of other disturbances, to pass into the tension-reduction phase, in which all basic problems of the political system (including the integrative) are felt to have been essentially solved. In this phase, high-quality art seems to have less social utility, and artistic stagnation is more likely to occur.

The main reason why artistic peaks do not tend to occur during the periods of most intensive political action seems to be the lack of resources which can be diverted from goal-oriented, and allocated to integrative, action. In the latency phase, however, the reduction in creativity occurs in spite of the possibility, frequently actualized in such periods (as in mainland Greece during and immediately after the Hellenistic era), of committing social resources on a large scale to artistic action. This suggests that the social utility of art may not necessarily be closely correlated with the empirical allocation of social resources to artistic creativity.

If artistic creativity increases during the periods of moderate disturbance of latency and during those of re-equilibration after radical disturbances, it may be hypothesized that the salience of the integrative need in the social system determines, to some degree, the qualitative level of artistic achievement. If, during intensive political action and after catastrophic defeat, social resources cannot be made available for artistically creative action, then, regardless of the integrative need, high-quality art cannot be created. In periods when the more tangible types of social resources cannot be supplied, the felt need for art may be satisfied by religious myths, other forms of oral literature, culturally patterned visions, dances, or other forms of artistic expression which require a smaller allocation of such resources than does the creation of most types of visual art objects.

But that the availability of social resources does not by itself guarantee a high level of artistic achievement is suggested by the tendency for artistic creativity to decline in the latency or tension-reduction phase, even when massive resources can be allocated to artistic action. It is therefore hypothesized that the degree to which social resources are committed to artistic action determines primarily the *amount* of art produced and affects its *quality* only when the allocation of resources to artistic action declines below the minimum level necessary to sustain organized art production at all. Such declines may be caused either by an "economic" deficiency of resources in the social system or by a "cultural" decision, as in Sparta, not to allocate existing resources to artistically creative action.

The present analysis tends to confirm the interpretation

offered in Chapter 2 that high artistic achievements do not reflect stable equilibria in the social system. Specifically, high-quality art is more apt to be created in a political system which, after a serious disturbance of equilibrium, is moving toward a new integration than in a system in which an adequate equilibrium is widely felt to have been attained or in one which is in the midst of an intense disturbance of equilibrium (or which for other reasons lacks the social resources required for effective reintegration).

Political phase cycles may cut across other types (economic, religious, communal) of phase cycles, and the effect of political cycles on artistic creativity may be modified or offset by the combined effects of the other types. Artistic creativity is presumably stimulated most when the integrative phases of several kinds of phase cycles coincide or overlap. A tradition of high art must, however, be present for any sociological factor to have an artistically stimulating effect. The cultural programs of states and political movements must also be considered, particularly in accounting for exceptional cases.

4. Ideological-Action Cycles

Ideological systems do not necessarily constitute an over-whelming influence on artistic expression; "great development-ments in art have often been remarkably separate from religious motivation and use." [1] This is particularly true in those preliterate societies like the Hopi (as contrasted to the Australian aborigines) in which women create most of the art. Symbolically elaborate ideological systems have, however, been generally available to artists in periods of creative efflorescence in the historic civilizations. To be sure, the presence of a complex religious or secular ideological tradition does not guarantee great artistic attainment.

Nor should one assume that different kinds of ideological systems have comparable effects on the quantity or quality of artistic creativity. "The Sudan can be eliminated" from a discussion of African art "because the people are mostly Mohammedans who are not allowed by their religion to represent any living form in their art." [2] Once a royal court or an urban-oriented society is established, however, a differentiation between the sacred and the secu-

lar tends to occur, and the creation of fine art becomes possible—indeed, likely—even in societies with iconoclastic religions, such as the Moslem or the Hebrew. An iconoclastic religion seems to have a permanently inhibiting effect on art only in tribal societies where there is little social basis for art other than the religious.

In the historic civilizations, secular ideologies do not appear to have promoted significant developments in visual art to the same extent as have some of the religious systems of the past. But an artistically stimulating secular ideology or a congeries of such interrelated ideologies is not theoretically inconceivable in an advanced industrial society—a unique, not yet fully developed type of civilization.

With the qualifications stated, historical evidence makes it possible to conceptualize the most general relationships between ideological action and artistic creativity—where they exist—in terms of the phase-cycle theory.

HISTORICAL ANALYSIS

An action cycle in the ideological system begins with a disturbance of a state of relative equilibrium. Ideological equilibrium may be said to exist when an established ideology is taken for granted in a society. If the disturbance of equilibrium is strong enough to produce an increased need for reintegration of the ideological system with the rest of the society, but not sufficiently radical (or rapid) to require an extreme degree of commitment of resources to ideological action, its effects on artistic creativity may be immediately stimulating. This may have happened in the seventh century B.C. in Greece, "the scene of a

religious renaissance which on all sides [threw] up new ecstatic confessions of faith, new secret cults, and new sects." [3] A similar process may have occurred in the Deccan area of India, where "toward the end of the sixth century, a cultural recovery set in, inspired by an enthusiastic revival of the cult of Siva." The kingdom of Guge, in western Tibet, "was the site of a revival of Buddhism in about the year 1000 and of the subsequent flourishing of Tibetan art." [4]

In medieval Europe, the spread of popular heresies as well as of religious crowd enthusiasm toward the end of the eleventh century [5] signified the beginning of the great reformation cycle. The heretical movement reached its height "during the three generations before the middle of the thirteenth century . . . in the rising towns of Italy and northern France." [6] This phase, however, did not lead directly to the transformation of Christianity. The early heretical movements were suppressed. The Renaissance emerged soon after the suppression of the first wave of heresy. It may be regarded as a product of the integrative reaction to the initial disturbance of the medieval ideological equilibrium. While the European middle- and lower-class "heretics have done nothing for art," [7] one must give them credit for an indirectly stimulating effect during the phase of integration which a powerful heretical movement, whether successful or not, makes necessary. Currents of popular mysticism, particularly those of the more emotional type, appear to affect art in a similar manner. Finally, most of the men composing the first two significant constellations of American artists grew up in periods of "great awakenings"—Copley, West, and Peale in the

1740's, and the Hudson School (Doughty, Cole, Durand, and even Church) in the early 1800's. The third great awakening, after the Civil War, does not correspond with the childhood of any group of artists of comparable significance. In industrial societies, artistic impulses have tended to be more detached from specifically religious ones than they were in earlier times.

As these cases indicate, the beginning of a disturbance of ideological latency and the subsidence of the disturbance, in the integrative phase, may both stimulate artistic creativity. However, a massive commitment of resources, in the goal-attainment phase, to religious or secular ideological action tends to deflect them from artistic creativity.

In the cycle of ideological action, the goal-attainment phase can be located in periods when a new ideology or a radical reform of an old one is struggling for dominance in a social system. A reduction in artistic creativity tends to occur in such periods. It is not, however, to be assumed that a *distinctive* goal-attainment phase can be identified in all processes of ideological transformation—particularly when the new ideology is not militantly proselytizing and when it is diffused at a relatively slow rate. In such cases, the initial-disturbance phase may lead directly into the integrative phase, with no clearly traceable adverse effects on artistic creativity. This may have been true of the spread of Buddhism in India (even though "the earliest Buddhist monks . . . ignored and even rejected art").[8]

The adverse direct effect of the ideological goal-attainment phase on artistic creativity may be illustrated from both art history and anthropology. The earliest historical case is somewhat ambiguous. The monotheistic reforma-

tion inaugurated by Ikhnaton (1369–1353 B.C.) imparted a naturalistic freshness to ancient Egyptian art, but one of the peak periods of Egyptian sculpture, 1580–1350 B.C., ended with the defeat of his reform movement.[9] Perhaps this attempt at a reformation can be interpreted as a disturbance of socioreligious latency—which should have had artistically stimulating effects. The artistic decline after the death of Ikhnaton can be explained partly by the definitiveness of the conservative reaction which defeated him, and partly by the fact that his religious reformation appears to have been imposed from above, instead of being a genuine popular movement which might have left disturbing by-products in the minds of men even after its defeat.

The spread of Christianity in the Roman Empire was associated with a decline in its artistic attainments [10]— though a combination of military reversals and economic depressions must be considered contributory circumstances. Conquering Islam demolished creative traditions as diverse as those of Coptic and Persian art.[11] The struggles of the Reformation coincided with reductions in artistic creativity in Germany, the Netherlands, and France in the second half of the sixteenth century. (A major reason for this decline was, of course, the fact that "where the Reformation was victorious, church patronage all but ceased to exist.") [12] In Africa, both native cultic innovations [13] and the diffusion of Islam and Christianity [14] disrupted vital artistic traditions. Missionaries had a destructive effect on American Indian art.[15] In Siberia, "the spread of Christianity" as well as of Lamaism "resulted in a decline of drawing and sculpture connected with shamanism." [16] Totali-

tarian societies, both Nazi and Soviet, offer more recent examples of a decline in the visual arts during periods of attempted institutionalization of a new faith. While efforts may be made to use art as a tool of ideological struggle in such periods, as a weapon for the forces of the old or the new, artistic quality is reduced by the submergence of art in intense ideological action.

In some of these cases, the new system of faith was coercively imposed, in others voluntarily chosen. In some, its spread coincided with foreign invasions; in others it was a domestic development. Introductions of a new faith have tended to be associated with radical disturbances in communal organization, and both processes may have contributed to artistic decline. But in general, it seems that, whether religious or antireligious, intense social action oriented to ideological goals tends to inhibit artistic creativity.

The Russian case is particularly interesting in its partial analogy, on a shorter time scale, to the Reformation cycle. In Russia, the disturbance of a relative ideological equilibrium by the rise of a secular religion, dramatized in the unsuccessful revolution of 1905, was followed, in what may be regarded as an integrative reaction to the initial disturbance, by the most creative decade in Russian art.[17] After 1922, however, the successful revolution of 1917 having initiated a period of intensive action in propagating the new faith (as well as in the political-economic sphere), creativity in the visual arts radically declined.[18] The ideological-action cycles of secular and supernaturalistic religions seem to have analogous effects on artistic creativity. In the industrial epoch, however, the phase movement seems to have been accelerated.

The struggle for dominance by a major ideological in-novation is frequently followed by periods of invigorated artistic creativity. In such a period, which may be regarded as the integrative phase of the ideological-action cycle, the new ideology or the reformation of the old has ceased to struggle for dominance, either because it has achieved success or has become resigned to partial failure.[19] (Socie-tal failures have been perhaps as productive for the ad-vancement of culture as have societal successes.) The artistic revival may begin immediately after the termina-tion of the period of ideological struggle or intense mis-sionary activity. But for its full fruition, it has seemed to require, in the preindustrial civilizations, from one to two centuries.

An efflorescence of sculpture, about 150 B.C.,[20] followed the official establishment of Buddhism in India about 240 B.C. In China, the relationship is less clear. The first traces of Buddhism appeared during, or even before, the first century A.D., but it was not until "around 200 A.D." that "Buddhism entered the country actively and brought an established tradition and manner of sculpture and painting." [21] Buddhism spread gradually and did not be-come fully Sinicized or widely popular until the fourth century A.D. An efflorescence of Buddhist-inspired art oc-curred in the sixth century, toward the end of "the period of domestication" of Buddhism in China,[22] and Chinese sculpture as a whole reached "its culmination about 700." The first peak period of Japanese art, 710–760, followed by about two centuries the importation of Buddhism in 522.[23]

In Europe, the official introduction of Christianity in the Roman Empire during the fourth century was fol-

lowed, in the fifth and sixth centuries, by "the flowering of the Christian art of Antiquity." [24] The peak of Hiberno-Saxon manuscript illumination occurred about a century after the beginning of the Christianization of Britain in 597. Frankish art began to show "promise" about two centuries after the Franks' conversion. A peak of Bulgarian art, in the tenth century, succeeded the conversion in 865.[25] The eleventh to thirteenth century efflorescence of the Kievan Rus followed upon Christianization in the tenth century.

Reforms within an established ideological tradition may have a similar stimulating effect on art. "The truly creative work" in West European manuscript painting during the twelfth and thirteenth centuries "was done chiefly in those monasteries which had been activated by the spirit of the Cluniac reform" [26] during the tenth and eleventh centuries. In Spain, the stringent ecclesiastical reforms of 1473 and 1512 (and also the establishment of the Inquisition in 1480) preceded the peak of artistic creativity by a century.[27] In Byzantium, the iconoclasm of the eighth century "seems to have had a refreshing influence on artistic production. . . . The second golden age of Byzantine art in the ninth and tenth centuries . . . could . . . rightly be called a result of the iconoclastic movement" [28] In the Netherlands, the artistic peak followed the Reformation by a little less than a century. After the Puritan "moral revolution" of the seventeenth century, English visual art achieved its first modern flowering in the eighteenth.[29] Ideological movements can do most for the arts by reforming themselves.

In each of these cases, ideological changes either oc-

curred in an organized state society or coincided with its establishment. In societies which have remained tribal, religious conversions have typically destroyed artistic traditions instead of revitalizing them. The existence of a state organization with a high concentration of social resources at its disposal may therefore be a condition for the artistically stimulating effects of radical ideological changes to be felt. The efflorescence of art one to two hundred years after the radical ideological reorganization of a state society suggests that, while artistic creativity tends to be reduced in times of institutionalization of ideological innovations, a radical upsetting of a relatively quiescent ideological situation by a reformation or a mass conversion (or even a large-scale attempt at one) [30] is likely to have a *long-range* stimulating effect.

To account for the stimulating effect of a radical disturbance of ideological latency, I assume that the social resources that are allocated to ideological action during periods of disturbance (and perhaps generated or mobilized during these periods) tend subsequently, if art is culturally legitimated, to be recommitted in part to artistic action. The period in which this recommitment mainly takes place is when the organizational problems of the ideological movement are widely perceived to have been essentially solved.[31] The task of articulating the ideological movement with the social-emotional structure of the larger society acquires primary salience.

In the relative absence of further disturbances, however, the integrative phase is eventually transformed into the latency phase, when a satisfactory (but "boring") overall equilibrium in the ideological sphere is felt to have been

attained. In this phase, the problem of integrating an ideology with the society is less urgent than in the one-to-two-hundred-year period after a radical disturbance of the ideological equilibrium. For this reason, the latency phase is likely to be a period of reduced artistic creativity, regardless of the extent of the allocation of resources to artistic expressions. In post-Reformation Holland, the decline started approximately 150 years after the beginning of the Reformation; in England, approximately two centuries after the Puritan Revolution. In both India and China, the decline in artistic creativity after the "religiously integrative" period took a longer time than in post-Reformation Europe, suggesting once again that ideological cycles have been accelerating in modern times.

The expiration of an ideological tradition may be regarded as another type of latency phase. Kroeber has pointed out that the gradual decline in the quality of Chinese sculpture after its peak around 700 was "contemporary with that of the Buddhist religion in the culture." [32] In particular, the violent destruction of Buddhism during the anti-Buddhist persecutions of the ninth century "dealt a death blow to a flourishing artistic tradition." [33] (However, according to Sorokin's estimate, the efflorescence of Chinese sculpture, though it had a peak period in 700–750, continued from 618 to 960.) [34] In India, Buddhism declined for several centuries; it had lost "the ear of the people" by the fifth century A.D.[35] and was supplanted "by the characteristically Hindu religiosity of love (*bhakti*)." [36] Possibly because a contemplative religion was being replaced by a more emotional one, an artistic peak period, 400–750,[37] coincided with the process. But as Hinduism

became overwhelmingly dominant and Buddhism "died out on most of the mainland . . . by about 1000 A.D.," [38] artistic creativity declined. The abolition of the Hawaiian religion in 1819 meant the end of Hawaiian sculpture.[39] It would seem that both the secure establishment of a religious dogma so that it cannot be effectively challenged and the complete submergence of a previously potent religious tradition reduce stimulation to artistic creativity.

To be sure, in the cases cited it was an artistic tradition linked with a specific religion that declined when the religion was submerged. With artistic traditions, such as the modern ones, that are not so closely connected with a particular ideology, the effects of the submergence of the ideology may not be so strong. But it is important that the submergence of a religious tradition does not stimulate art, as might be expected if it was assumed that the liberation of art from the shackles of religion promotes artistic creativity.

These observations point to the utility of ideological reformations within a society at approximately two-hundred-year intervals as stimuli to cultural creativity.[40] If they occurred much more frequently, they might not allow enough time for reintegration of the socio-cultural system and for the full unfolding of creative potentialities during the reintegrative process. At much less frequent intervals, each reformation might lose its challenging edge, as Protestantism had by the second half of the eighteenth century on the European continent. If, however, the historical cyclical movements have accelerated (as have other kinds of social change), religious or secular ideological reformations may, in the modern period, be needed for

cultural revitalization at more frequent intervals than in the past.

While the evidence is far from being unambiguous, it suggests that, insofar as the dynamics of ideological action are related to artistic creativity, the relationship has the following pattern: Artistic creativity is stimulated when a condition of relative ideological equilibrium is disturbed by a rising wave of reform; reduced during periods of rapid institutionalization of a new ideology or reformation of an old one; increased again in the phase of integration of ideology with society which follows periods of major ideological innovation; and reduced in the subsequent phase, when an ideology has either securely established its dominance or has disappeared without being replaced by a dynamic and emotionally convincing substitute.

CONCLUSION

In accounting for this pattern, it is suggested that in the ideological cycle latency reduces, and disturbance of latency increases, the need for reintegration of ideology with society (especially its communal subsystem). This need is assumed to determine the social utility of art as an integrative factor. While fashion, rather than integrative need, may also cause a demand for art, particularly perhaps in periods of latency, it seems plausible that the greater the social utility of art, the greater will be the allocation of available resources to artistic action (unless they have to be diverted to direct social action, as during the goal-attainment phase, or art is culturally disvalued).

Social resources are not sufficient, however, to sustain a high level of artistic attainment in the absence of a highly

salient integrative need in the social system. Artistic creativity therefore tends to decline in periods of socio-ideological latency, when the dominance of a system of faith is securely established and the integrative need, in this subsystem of society, declines—no matter how extensive the allocation of resources to artistic action.

5. Communal-Action Cycles

The theory developed in earlier chapters suggests that artistic creativity tends to be inhibited when any subsystem of the society approaches a "steady state" and when intensive action is going on in the subsystem. Conversely, artistic creativity appears to be stimulated by a disturbance (though not an overwhelming one) of a relatively "steady state," and by the need to effect reintegration of the social system after a period of intensive change in any of its subsystems. In this chapter, the theory is tested by applying it to the dynamics of communal integration and disintegration, which are regarded as analytically separable from (though interrelated with) political, economic, and religious processes.

The community, as a subsystem of the society, may be conceived of as the sum of "patterns for reaching consensus, for balancing loyalties, for distributing rewards, and for sharing authority." [1] The state of equilibrium of a community may be determined by the degree to which manifestations of group struggle, from verbal attacks to revolutions, are absent. Although the rates of suicides or

of illegitimate births [2] also provide measurements of the degree of community integration, these indicators—available in any case only for the recent past—seem to be more adequate for measuring the integration of individuals within groups than the integration of groups within the total society. It is primarily the latter, macrosocial kind of integration that is of concern here.

Although it cannot be assumed that community systems ever attain perfect equilibrium, they vary over time in the degree to which they approach this condition. Movements toward equilibrium may be identified as integrative trends, and movements away from it as disintegrative trends. Periods that most closely approximate equilibrium may be regarded as the latency phases of communal cycles. Operationally, a disturbance of latency should be indicated by a rising rate of manifestations of internal struggle after a prolonged period of domestic peace, and a movement toward reintegration should be reflected in a declining rate (if there are long-range consistencies in the incidence and magnitude of internal disorders).

LONG-TERM PHASE CYCLES OF INTERNAL DISORDERS

Since national artistic efflorescences tend to develop over lengthy periods, frequently measurable in centuries, short-term variations in the scale of domestic disorders may have little bearing on them. If it takes centuries to build up an artistic climax, one might argue, it is not the particular, historically "accidental" civil disturbance (however disintegrative in its immediate effects) but the ascending or descending trends in the magnitude of civil disorders that should be related to the artistic development. It is

these long-term trends that can be regarded as indicators of the movement of the whole society toward or away from a communal equilibrium.

As a measure of these long-term trends, Sorokin's data on fluctuations in internal disorders [3] will be converted into the categories of the phase-cycle theory on the basis of the following tentative operational assumptions: (1) Disturbance of latency is indicated by a century of minor increase in the index of internal disorders after a century or more of decline or essential stability at a low level. (2) A goal-attainment phase (marked by a reorganization of institutions) is located in a century, or longer period, of sharp increase in the magnitude of internal disorders, which is followed by a century of decline in the disorder rate.[4] (3) An integrative phase may be identified as a century of decline in the magnitude of internal disorders, subsequent either to a disturbance of latency or a goal-attainment phase. (4) A latency phase is signified by a period, following the integrative phase, of further decline or of essential stability in the index of internal disorders.

When the data are rearranged in accordance with the above definitions, an imperfect but definite approximation to the phase-cycle pattern is evident (Table 1). The imperfection consists in one phase or another being "missing" (although it has been possible to define the integrative phases of all cycles). This type of imperfection should not be surprising, in view of the grossness of the data and the purely heuristic procedure of arranging them by centuries. Furthermore, while the phase-cycle theory implies that if there is a latency phase it must always be preceded by the three prior phases, it does not require any specific historical cycle to conclude with a definite latency phase. A cycle

TABLE 1. COMMUNITY-INTEGRATION CYCLES DEFINED BY
THE PREVALENCE OF INTERNAL DISORDERS

Country	Disturbance-of-latency phase	Goal-attainment phase	Integrative phase	Latency phase
Greece	600–500 B.C.	500–400 B.C.	400–300 B.C.	300–150 B.C.
Rome			500–400 B.C.	400–200 B.C.
	200–100 B.C.	100–1 B.C.	1–100	100–150
	150–250	250–350	350–450	450–500
Byzantium				526–600
	600–700	700–800	800–900	
		900–1000	1000–1100	1100–1150
	1150–1250			
France				526–600
	600–700	700–800	800–900	900–1000
	1000–1100	1100–1200	1200–1300	1300–1350
	1350–1450		1450–1550	
	1550–1650		1650–1750	
		1750–1850	1850–1930	
Germany and		700–800	800–900	900–1000
Austria		1000–1100	1100–1200	1200–1300
	1300–1400		1400–1500	1500–1750
	1750–1850	1850–1930		
England		700–800	800–900	900–1000
	1000–1100		1100–1200	
	1200–1300		1300–1400	
		1400–1500	1500–1600	
		1600–1700	1700–1800	1800–1930
Italy				500–600
	600–700	700–800	800–900	
		900–1000	1000–1100	1100–1200
	1200–1300	1300–1400	1400–1500	1500–1750
	1750–1850	1850–1930 (?)		
Spain			500–600	600–700
		700–800	800–900	900–1000
	1000–1100		1100–1200	
	1200–1300	1300–1400	1400–1500	1500–1800
		1800–1900		
Netherlands			700–800	800–1000
	1000–1100	1100–1200	1200–1300	
		1300–1400	1400–1500	
	1500–1600		1600–1700	1700–1750
		1750–1850	1850–1930	

Source: Data derived from Pitirim A. Sorokin, Social and Cultural Dynamics (New York: American Book Company, 1937), III, 412, 418, 422, 428, 434, 440, 447, 455, 459.

may be interrupted by the beginning of a new cycle before reaching its natural termination. If no sharp intensification of action takes place, the goal-attainment phase may not be specifically distinguishable from the disturbance of latency. When these considerations are held in mind, the data do seem, with no more than expectable imperfections, to fall into the theoretical pattern of the phase cycles.

It is, of course, not assumed that the phases begin, with an insane precision, in the first year of a century and end in the last. Rather, since the data are not being analyzed at this point by any smaller time units, it is only the main direction of a century that analysis can register. This direction—the "actual" equivalent of a postulated cycle phase—may have begun to manifest itself, as a closer inspection of the historical record would reveal, as much as several decades before or after the beginning of a century, as conventionally dated, and it may have terminated on either side of its "official" end.

To determine the effects of communal-integration cycles on artistic creativity, the data in Table 1 will be compared with the evidence on historical fluctuations in artistic creativity. The identifications of artistic peaks are based on Sorokin's judgments, as modified in Chapter 2, above, to conform with the current consensus of art historians, and are supplemented with data on the Byzantine civilization. Artistic peaks appear to have occurred in the following periods: Greece, 559–300 B.C.; Rome, 30 B.C.–A.D. 110; Byzantium, fifth to sixth, and ninth to tenth centuries; France, 1140–1325, 1760–1910 (1820–1930); Germany and Austria, 1120–1260, 1400–1560, 1800–1900 (1900–1930); England, 1220–1250, 1715–1850; Italy, 1420–1600 (1680); Spain, 1580–1660; the Netherlands, 1580–1660.[5]

The hypotheses that artistic creativity is stimulated by disturbances of latency and reduced in the latency phase are given some support by a comparison of the data in Table 1 with the judgments about the estimated peaks of artistic creativity.[6] Four peaks (Greek; German, 1400; English, 1220; Dutch) begin, and two (Byzantine, 600; English, 1250) terminate in the disturbance-of-latency phase. Conversely, only one (Spanish) begins [7] and seven (Greek; Roman; French, 1325; German, 1560; English, 1850; Italian; Spanish) terminate in the latency phase. The other two hypotheses obtain little if any support from the present comparison. While the goal-attainment phase was expected to reduce artistic creativity, three peaks (Roman; French, 1140 and 1820) begin, and two (Byzantine, 1000; German, 1930) terminate in this phase. This distribution is not different from five beginnings (Byzantine, 800; German, 1120 and 1400; English, 1715; Italian) and three terminations (Byzantine, 1000; French, 1930; Dutch) in the integrative phase, in which artistic creativity should have been maximized. One has to conclude that in this analysis no artistically inhibiting effects have been shown for the goal-attainment phase, or stimulating ones for the integrative. It may be that the index used here is more adequate for identifying latency and its disturbances than for distinguishing between the phases of goal attainment and integration.

A peculiarity of this index is that it separates "domestically generated" civil disorders from disturbances of the community that have been caused by, or expressed through, interstate wars. For this reason, Germany in the first half of the seventeenth century has been identified as being in the phase of communal latency. While the communal sys-

tem may have been stagnant during this period, in the sense of being unable to generate any dynamic forces of its own, it was stagnating (due to the destructive impact of the Thirty Years' War) in a highly disturbed condition. Perhaps the concept of communal latency should be viewed as implying, not the absence of disturbance, but the lack of energy for challenging existing institutions and for building new ones in the community system.

As a further test of the approach adopted in this section, Lee's data on internal disturbances in China from 221 B.C. to 1929 [8] will be reanalyzed in terms of our operational definition of the phase-cycle movement. All three peaks of painting (as estimated by Sorokin), circa 750, 960–1200, and 1450–1500,[9] have started in integrative periods. The sculpture peak of 618–960 began in a goal-attainment phase. The three painting peaks terminated at the beginning of disturbance-of-latency, goal-attainment, and latency phases, respectively. Contrary to expectation, the sculpture peak ended during an integrative phase. In this case, however, the artistic efflorescence continued, since "a remarkable revival of painting" began just then.[10] The integrative phase seems to be associated with artistic efflorescences. No other pattern is clearly indicated. The Chinese data conform with the European in not showing any definite adverse effect of the goal-attainment phase on artistic creativity.

The data surveyed might be interpreted as suggesting that intrasocietal aggressiveness has a stimulating effect on latent creative motivation. Two types of considerations argue against an unqualified acceptance of this interpretation. First, artistic creativity tends to be maximized in

periods of *moderate* domestic violence (whether of increasing violence, as more frequently in Europe, or of declining violence, as in China). Second, the aggressiveness theory cannot account for most of the cases discussed in the following section, whereas the phase-cycle theory can. Since the latter can also explain why creativity increases in periods of moderate internal disorder, it seems preferable.

INTEGRATIVE AND DISINTEGRATIVE TRENDS IN THE COMMUNAL SYSTEM

In the preceding section, systematic data on civil disorders were used as an index of communal-integration cycles. This approach had advantages: the collection of data was independent of the formulation of the present hypothesis, and the data were exact enough to provide a sort of quantitative test of the theory proposed. Open to question, however, are the assumptions both that secular trends in the volume of domestic disorders provide a valid indicator of the degree of communal integration and that hundred-year periods are meaningful "slices" of historical processes. Therefore, another method of testing the theory will be employed in this section. Several types of specific historical processes involving communal integration and disintegration will be related to fluctuations in creative artistic achievement. This approach entails the danger of selective use of the data, but it does permit a more concrete analysis of historical processes.

Significant artistic peaks have in a number of cases occurred in periods following a major reformation of the community system. One case in point is the *amalgamation* of different ethnic strains into a cohesive community. In

China, the T'ang artistic efflorescence during the seventh and eighth centuries occurred after the fifth-century Sinicization of the Turko-Mongolian invaders who had arrived during the fourth century. "T'ang painting was undoubtedly to show greater power but, at least in its beginnings, less subtle grace, perhaps because North China, where T'ang art was to develop, had in the interval absorbed the Turko-Mongolian hordes established on its soil for more than two centuries." [11]

In Europe, "Italy gradually attained political, linguistic, and cultural unity after the Roman conquest. This process was actually completed only during the first century B.C." [12] It was during this century that the most creative period of Roman art began: in sculpture, 30 B.C.–A.D. 100; in painting, 50–100 A.D.[13] The flowering of the pictorial arts in England during the twelfth century occurred after the Norman tradition of miniature painting had had time to fuse with indigenous art traditions.[14] The artistic fusion was but one element of the sociocultural integration following the Norman conquest. These cases suggest the hypothesis that spontaneous integrative processes in the communal system, such as a fusion of different ethnic strains, may give an impetus to artistic creativity, partly through cross-fertilization (as well as a release from the limitations of any particular cultural tradition) and partly, perhaps, by increasing the social need for art as a symbolic means for community integration.[15]

A basic *reorganization* of the fundamental institutions of a society has also preceded periods of great artistic creativity. The fifth-century peak of classical Greece followed two centuries of social reorganization, during which an

aristocratic government displaced the monarchy, a money economy and slavery were developed (strengthening the middle class sufficiently for it to challenge the hold of the nobility), Draconian and Solonian legislation was put into effect, and, in 510 B.C., democracy was introduced in Athens. In Etruria, the seventh to the early sixth century B.C. "saw the establishment of an urban society, . . . the specialization of industries and crafts," and then "civilization reached its artistic climax between the 6th and 5th centuries." [16]

In late-medieval Europe, the rise of the Gothic style, about 1150, and of the renaissance movement, about 1300, followed the eleventh-century urban revival, the emergence of the commercial middle class, and the formation of administratively autonomous municipalities. In Italy, where "the crisis" developed first, it "reached its climax in the late eleventh and early twelfth centuries, when power passed in the towns from the feudal overlord or bishop to organized groups of citizens." The second half of the twelfth century saw the period of guild organization both in Italy and "in towns of central and north-western Europe," [17] where the Gothic was concurrently emerging. While the best period of the Gothic would thus seem to be located in the goal-attainment phase of the development of medieval urban communities, the Renaissance developed in what, from this point of view, can be regarded as the integrative phase.[18]

In Greece and in late-medieval Europe, while the peak of artistic creativity was achieved after reintegration, the goal-attainment phase was also one of increasing creativity. Thus this phase, if it extends over a period measured in

centuries, does not actually exert a depressive effect on creativity, but merely fails to give it maximum stimulation. However, rapid (revolutionary) reorganizations, while potentially stimulating in the long run, are likely to have an immediate adverse effect on art. Such was the effect of the Puritan revolution in England. (Its religious aspect is discussed in Chapter 4.)

In the modern age particularly, revolutions and civil wars can be regarded, in part, as highly concentrated processes of communal reorganization. They have often been followed, within decades, by artistic efflorescences. While the American Revolution did not stimulate the visual arts, the artistic tradition of France was vitalized by the defeat of the French Revolution. American art grew "toward maturity in the hands of the post-Civil War generation." [19] Although in South America "no great art expression resulted from these [revolutionary] upheavals of the nineteenth century," [20] possibly because of the lack of a still producing domestic tradition of high art, "the excitement of Mexico's artistic revolution" of the twentieth century "succeeded the political one by about ten years." [21] Not only the successful revolutions, but also revolutionary failures, by disturbing tendencies toward communal latency, may contribute to revitalizing art. The Paris Commune was immediately followed by the "best period" of impressionism, and the abortive Russian revolution of 1905 by the most productive twelve years of modern Russian art. The acceleration of historical processes in modern times may explain the rapidity with which artistic revivals have followed upon social disturbances.

While the Russian revolution of 1917 may have had

some artistically liberating effect until 1922,[22] it soon became artistically repressive, partly by virtue of the continued emphasis on the attainment of political and economic goals under an increasingly totalitarian regime. A similar emphasis had similar results in Nazi Germany and Communist China. A suggested explanation of the less negative effects on artistic creativity of totalitarian dictatorships in Italy and Cuba is that these countries have concentrated less rigidly—in a less "Prussian" manner—on goal attainment than the more completely totalitarian systems have.

In general, the instrumental tasks of rapid and radical institutional reorganization require such a heavy commitment of social resources (and, if it takes place violently, their destruction) that, unless immense reserves are available, they have to be largely withdrawn from activities oriented toward communal reintegration. But once the reorganization goals have been attained, resources can be increasingly released for integrative action. A radical social reorganization, without being a sufficient precondition for an artistic efflorescence, may be one of several possible preconditions.[23]

Thus both spontaneous communal reintegration after a disturbance and formal institutional reorganization may be followed by artistic efflorescences. In this chapter, the two types of processes have been illustrated by different historical cases. It may be assumed, however, that whenever institutional reorganization occurs, it creates a need for a socioemotional reintegration of the communal system. While in specific historical situations the integrative phase may overlap with the reorganization process, our

cases suggest that artistic creativity tends to be increased in periods of gradual reintegration of personal emotions, social actions, and cultural meanings in a previously disturbed communal system, and reduced in times of rapid, enforced reorganization of its institutions. The latter type of period seems to represent the quintessential effect of the goal-attainment orientation on artistic creativity. In periods in which institutional change is gradual, it is likely to be interwoven with spontaneous integrative trends at the social-emotional level. If the latter have a stimulating effect on art, our failure to discover a reduction in artistic creativity during prolonged goal-attainment phases may be accounted for.

Impressionistic observations suggest that *disintegrative* tendencies may also have an artistically stimulating (though perhaps a minor and more short-range) effect. Hauser apparently refers to the creativity of social disintegration in his observation about seventeenth-century French art: "The genius whom the age of Louis XIV, with its state commissions, scholarships and pensions, its Academy, its school of Rome, and its royal manufactory, was not able to produce, is begotten by the bankrupt, headless, frivolous Regency with its lack of piety and discipline." [24] The artistic exuberance of early Weimar Germany also developed in a context of social disintegration. Hoffer has suggested that periods of cultural creativity tend to precede (although they are even more likely to follow) those of the most intensive activity of mass movements.[25] Creative periods are presumably those when disintegration, which will later break out in a mass disturbance, is beginning to be clearly felt. Disturbances of communal latency

have been shown, in the preceding section, to have artistically stimulating effects (though this has not been demonstrated for China). Similar observations have been made in Chapters 2 and 3, above, with regard to incipient economic and moderate political disturbances. The very diversity of the examples cited supports the hypothesis that art, like religion, may develop as a means of coping with social disintegration—which in turn, when it is not induced by external pressures, may occur as a response to the boredom produced by communal latency. It is difficult to ascertain, however, to what degree artistic creativity depends on the presence of integrative trends in a situation of disintegration,[26] and to what degree disintegration itself, by diverting resources from purposive action or by increasing the social utility of art, may enhance the artistic response.

Communal disintegration may also have an adverse effect on the arts, particularly if it is both rapid and radical or if it occurs under the intrusive impact of a more powerful civilization. The first condition developed during the Thirty Years' War in Germany. The second can be illustrated by the tribal African societies in which communal disintegration, under the impact of Western influences, "has so changed social and cultural conditions that the traditional art has lost its deepest reasons for existence, and artists and craftsmen are gradually abandoning sculpture." [27] But "in the societies, rare as they are becoming, that have succeeded in maintaining a certain level of cultural integration, traditional art subsists and continues to display an unquestionable vigor." [28] In the United States, "the pressures of assimilation not only tended to eradicate

Indian culture, but also made many Indians refuse to follow tribal arts, which they regard as a step backward. In their desire to identify with the non-Indian group, they rejected as many Indian characteristics as possible." [29]

One reason for the disappearance of sculpture in some regions of Africa was the "destruction of those institutions that patronized the sculptor." [30] But a decline in artistic creativity has accompanied the collapse of traditional community organization in the Northwest Coast Indian societies, in spite of the continuing demand by white traders for native art. Their art was, however, no longer as urgently needed as before, in the community to which the artists could perceive themselves as belonging and with which they emotionally identified themselves. It was bought by outsiders whose judgment of art was emotionally irrelevant to the artists (outsiders, furthermore, who lacked a proper appreciation of it). The situation did "not bring forth the finest efforts of carvers." [31]

Among the Senufo of the Ivory Coast, "working for an unknown customer of a foreign race" has encouraged mass production of mediocre carvings, but a few "real artists" were liberated from the hold of tradition to develop more original personal styles. They seem, however, by and large, unable to develop the originality which the breakdown in the integration of art with the community has made possible: "Most of these new personal styles are weaker than the traditional Senufo styles." [32] A complex social organization, in which different kinds of trends can be going on at the same time, seems to be necessary for communal disruption to have beneficial effects on art. The qualities of organization which render a society capable of culturally

benefiting from socially disruptive shocks still need, however, to be identified.

As a partial explanation of the observations cited, it is suggested that a gradual and prolonged trend toward either communal disintegration or integration (as contrasted with a relatively "steady state") may increase the social utility of art as a medium for socioemotional reintegration, without necessarily destroying or massively diverting the resources needed for artistic creation.

In contrast, a rapid, comprehensive disintegration or swift, radical reorganization seems to inhibit artistic creativity, presumably because such processes entail either a large-scale destruction of resources essential for artistic creation or an extreme degree of their commitment to instrumental action. While the need for art as an integrative factor is presumably increased during such periods as well, sufficient resources cannot be provided for artistic creation, and creativity declines. Both the need and the resources are present *after* a successful reorganization of the communal system. In such periods, therefore, artistic efflorescences seem most likely to occur; they may in fact contribute, at the symbolic level, to the attainment of communal integration.

This interpretation seems to be preferable to Sorokin's theory that artistic efflorescences occurring after natural or social "calamities" can be accounted for by a tendency for aggressive "reactions" to be offset by creative "counterreactions." [33] While such counterreactions may indeed be *necessary* if a social system is to restore an adequate degree of equilibrium, Sorokin's theory does not explain, in any systematic way, the sociological mechanism which makes

them *possible,* although he does refer to "an urgent sense of need" that stimulates "efforts to create the needed system" and to the "abnormal mobility" during such periods.[34] Furthermore, it is not only calamities but also reorganizations which have an artistically stimulating effect. The theory presented in this chapter seems to be capable of accounting for both types of processes in terms of a single sociopsychological mechanism.

With the socioemotional consolidation of the community, the utility of art as an integrative factor should decline. This may account for the "definite signs of exhaustion" in Chinese art [35] during the Han "period of community consolidation." [36] While serious integrative problems had to be faced in the earlier part of this period,[37] an approximation to a latency phase appears to have occurred later, with adverse effects on art. The decline of Dutch art in the eighteenth century is another example of this tendency. The hypothesis that a protracted period of latency in the communal system has adverse effects on artistic creativity is also supported by Sorokin's data analyzed in the preceding section.

CONCLUSION

In this chapter, the phase-cycle theory of artistic creativity has been tested in relation to processes of communal integration and disintegration. Sorokin's quantitative data on internal disorders have been fitted, by a series of operational assumptions, into the theoretical structure of the phase-cycle theory. A number of more specific cases utilizing descriptive data have been considered.

The combining of both types of data permits a revised

conception of the communal-integration cycle: (1) the disturbance-of-latency phase is indicated by an increase in manifestations of group struggle, suggestive of a change in attitude toward the *status quo;* (2) the goal-attainment phase is focused on a radical (either "peaceful" or "violent") reorganization of social institutions; (3) the integrative phase is dominated by spontaneous trends toward reintegration of the community around the reshaped institutional foundations; and (4) the latency phase is marked by a prolonged relative absence of manifestations of group struggle, indicative of the emergence of an attitude that takes established social conditions for granted. At any given time, specific segments of a complex social system may be passing through different phases of this cycle.

The manner in which artistic creativity appears to be influenced by the communal-integration cycle may be briefly described as follows: (1) The social utility of art is increased in periods of high salience of the integrative problem in the community system.[38] These are the periods of disturbance of communal integration. (2) High-quality art can be created only when adequate social resources are allocated to artistic action. Such allocations are likely to increase after radical community reorganization or attempted reorganization. However, the availability of social resources for artistic action is not, by itself, sufficient to guarantee a high level of artistic attainment. For this to be possible, high salience of the integrative problem must be combined with great availability of resources. When the salience of the integrative need declines, during the latency phase, artistic creativity also tends to decline, in spite of the possibility of a large-scale allocation of re-

sources to artistic action. It is assumed, however, that only if art is culturally legitimated and a well-developed artistic tradition is available can sociological processes have a significant effect on artistic creativity.

Neither artistic creativity nor communal integration can be precisely defined or exactly measured. Yet they constitute major variables in cultural and historical sociology. Their relationships therefore deserve exploration, even though it may yield more hypothetical conceptualizations than definitive conclusions.

II. PSYCHOHISTORICAL DYNAMICS

6. Achievement-Motivation Cycles

The frequently evident decline in artistic creativity in the later, most prosperous stages of economic advancement [1] can be explained, not only sociologically, by the reduced salience of the integrative need in the social system, but also psychohistorically, by the dynamics of the achievement drive in the personality system as it relates to processes of economic growth.

HISTORICAL EVIDENCE

Achievement motivation may be defined as subconscious preoccupation with "doing well" in accordance with some standard of excellence. This type of motivation apparently tends to be strong in periods preceding rapid economic growth and is greatly reduced in periods following rapid economic growth. David McClelland has devised a way of measuring the level of the achievement drive that found expression in the literature and visual art of the past. Strictly speaking, art works reveal the strength of the achievement drive only of their producers—that is, the artists. But since the creations analyzed by McClelland and

his associates were widely popular at the time of their production—and apparently in different types of groups within the society—the assumption seems justified that they reflect the general level of achievement motivation and, particularly, its changes over time.

Using McClelland's method of measurement, D. E. Berlew and E. Aronson have demonstrated that the need for achievement was strongest during the "growth" stage of the Greek civilization (900–475 B.C.), declined during the "climax" (475–362 B.C.), and was still further reduced in the "decline" phase (362–100 B.C.).[2] The same pattern was traced by E. Davies as developing in Minoan Crete between 2600–1400 B.C.[3] In Spain, the climax in painting can perhaps be placed, if El Greco is included, in the period from 1580 to 1660; and four different types of literary indexes of the need for achievement presented by J. B. Cortés show that it was declining from 1200 to 1750. In their analysis of American children's readers, R. de Charms and G. H. Moeller have demonstrated that there was an increase in the frequency of achievement imagery up to 1890 and a continuing decline in every decade from 1900 to 1950.[4]

In these four cases, the attainment of economic prosperity is associated with both a lessening of achievement motivation and an increase in artistic creativity. However, the first significant growth of modern English painting, in the eighteenth century, coincided (as N. M. Bradburn and D. E. Berlew have shown) with a period of increasing need for achievement—which McClelland attributes to the Wesleyan revival. (The need increased primarily in the "middle and lower classes," to which Methodism had its chief appeal. Achievement motivation appears, in fact, to have

declined, after the middle of the century, in the ruling class.) [5] This case suggests that an ideological revitalization movement may be necessary to reverse the typical long-term trend, in economically successful societies, toward a reduction in achievement motivation.

Presumably, the attainment of a relatively high level of prosperity can be felt to be sufficiently gratifying to legitimate the diversion of some motivational energy from achievement-oriented to other kinds of activities, including self-expression.[6] One factor mediating between prosperity and achievement motivation is child training. H. Barry *et al.,* in a study of 104 societies, mostly nonliterate, found an inverse relationship between economic accumulation and the emphasis in child socialization on achievement, self-reliance, and independence, qualities which probably become less critically needed with the attainment of prosperity.[7]

The Greek and Spanish data, however, suggest that it is in the transitional period of declining achievement motivation—after a high level has been reached—that artistic creativity may be most stimulated. Extremely low achievement motivation, after a period of continuous decline, appears to be associated, not only with a demand for material luxury or, on a lower economic level, with a resigned acceptance of poverty, but also with a reduction in artistic creativity. This suggests that artistic creativity may in general be linked with changing patterns of motivation and that, consequently, high-quality art may have socially integrative and psychologically stabilizing functions to perform (which luxury in itself, presumably, does not).[8]

These inferences are borne out by the observations of an

economic historian on Renaissance Italy. "After the first decades of the thirteenth century and in the first half of the fourteenth . . . the urban economy of medieval Italy may be said to have entered its prime." But "by the fifteenth century," toward the culmination of the Renaissance, "Italy no longer occupied the same place in the economy of Europe as in the two preceding centuries. . . . The old power of expansion was enfeebled," partly because of what seems to have been a reduction in the achievement drive: "The new aristocracy of money" tended by now "to withdraw . . . capital from industry and trade and invest it from motives of security and social prestige, in town and country properties." This was, however, a period of continued prosperity, and "during the fifteenth century court life in Italy attained its highest point of splendor." [9] The forfeiture of artistic leadership by the Italians soon after the High Renaissance may be associated with a hypothetical further decline in achievement motivation.

MOTIVATIONAL INTERPRETATION

The evidence suggests that increasing prosperity tends to reduce the motivation for achievement. But as the direct correlation between affluence and artistic interest indicates,[10] increasing prosperity should strengthen the motivation for expressive action. It is in the historically extended moment when the two types of motivation are, in a manner that is at present not precisely definable, balanced in strength that highest-level artistic achievements are most probable.

The presumed reason for this finding is the inherent

dependency of artistic creativity on the presence, in a well-developed form, of *both* types of motivation. A "strong drive for achievement" has indeed been revealed by psychological tests given to contemporary artists,[11] as well as women with imaginative and artistic interests [12]—that is, among people in whom we would ordinarily expect a strongly developed drive toward self-expression as well. Experimental studies of scientists have shown, however, that "less creative" scientists have higher need-for-achievement scores than the "more creative" ones,[13] and the same may be true of artists. Extremely strong achievement motivation is apt to result in direct, less symbolic expression [14] —in violent social action or in relatively unimaginative cultural products. On the other hand, a "negative correlation" between good aesthetic judgment and "love of comfort, relaxation, and friendly social relationships"—tendencies suggestive of a weak achievement drive—has been found in two experimental investigations of American college students.[15] Art is an *achievement* in self-expression. And it may be that one needs a considerable drive toward achievement even to appreciate the quality of the achievements of others.[16]

With a further increase in economic prosperity, achievement motivation tends to decline further, and expressive motivation to become still stronger. This combination may be sufficient, on the one hand, to terminate economic advances [17] and, on the other hand, to result in the further growth of a self-conscious interest in art works as objects of luxury to which no profound emotional significance need be attached. But in this stage achievement motivation becomes inadequate to sustain creative attainment of the

highest order, even in the production of art. (It may even adversely affect aesthetic judgment, as the experimental evidence just cited suggests.) Indeed, once this stage is reached, an *increase* in achievement motivation, possibly caused by an ideological revitalization movement,[18] may stimulate the capacity to create great art (as perhaps happened in England during the eighteenth century).

Low achievement motivation can also be found at the lowest levels of socioeconomic development; it was apparently characteristic of the Eskimos [19] and the now extinct Tasmanians,[20] and it may indeed have been one reason for their lack of economic advancement. Impressionistic observations of individual Eskimo artists indicate, however, that they may have stronger achievement drives than is generally characteristic in their societies.[21]

A specific psychological factor which has been identified as favoring artistic creativity is a relatively balanced tension in the personality system between the drives toward achievement and toward expression. The "unrelaxing energy of imagination," "the sense of energy communicated by the New York School" that impressed foreign observers as more frequently present in "the best American art" of the 1960's than elsewhere may have been an indication of the relative balance, in the personality systems of successful American artists of that period between the drives toward self-expression and toward achievement.[22]

A very real problem, which our data do not help much to resolve, is whether, in a highly differentiated society, these types of motivation must be present only in the personality systems of creative minorities or whether they must be more generally prevalent in order to make possible an

artistic efflorescence. Intuitively, it seems more essential for creative people to have such motivation. However, if there is extensive movement into the artistic profession (rather than inheritance of professional roles), the achievement motivation of artists must be assumed to be interrelated with, and affected by, that of the general population. Presumably, the motivations characteristic of the groups from which artists have not been extensively recruited in the past—e.g., the urban lower class—have been largely unrelated to fluctuations in artistic creativity in the course of history. Such groups may acquire artistic significance in the future, if a genuinely "populist" civilization develops in advanced industrial societies.

PSYCHOECONOMIC CYCLES

It is possible to conceive the data surveyed in this chapter in terms of an extremely long-range psychohistorical (or motivational) cyclical movement of a special type. The cycle phases referred to in this and the following two chapters may be defined as follows: The latency phase occurs when impulses that would probably upset a quiescent state of the personality are least likely to originate in the type of motivation subsumed under a particular type of psychohistorical cycle. (The motivational system in question is underactivated, in a state of "boredom".) Disturbances of latency take place when such impulses begin increasingly to originate in this particular motivational system. In the goal-attainment phase, the highest rate of equilibrium-upsetting impulses arises within the type of motivation conceived as changing in the course of the cycle. The phase of integration is characterized by the growing tendency for

this type of motivation to become permeable to, and articulated with, other elements of the personality system, thus helping to stabilize it.

Given this provisional conceptualization of psychohistorical cycles, the empirical observations cited earlier in this chapter suggest that artistic creativity tends to be inhibited in the latency phase, characterized by a low achievement drive, regardless of the level of economic attainment. Creativity may be stimulated by a disturbance of motivational latency—by an increase in the achievement drive at a time when it is low (as in eighteenth-century England). But artistic creativity does not reach its peak when achievement motivation is strongest, in what might be identified as the goal-attainment phase of the *psychoeconomic cycle*. Creativity keeps increasing as achievement motivation declines. The peak of artistic creativity tends to occur when the motivations toward achievement and toward expression are, in some manner, balanced against each other. This may be regarded as the integrative phase of the psychoeconomic cycle. The cycle concludes with a further reduction in achievement motivation, accompanied by a decline in artistic creativity—the latency phase.

While a high level of achievement motivation tends to initiate the psychoeconomic cycle by causing behavior leading to a reduction in achievement motivation, a low level of the achievement drive may become stabilized in a social system (or any one of its components) and preclude the emergence of a psychoeconomic cycle. This should have an unfavorable effect on artistic creativity.

7. Culture-Mentality Cycles

The concept of psychohistorical cycles may also be employed in investigating the relationship between artistic creativity and changes in basic cultural orientations. Past theorizing on this relationship has not been particularly consistent. An inverse relationship between "the religious passion" and artistic creativity has been postulated by Ruskin, while Chambers, Clark, and, "on the whole,'" Mukerjee maintain that the ages of highest artistic attainment have also been those of strong communal faith.[1]

The more detailed quantitative data which Sorokin has presented appear, with all their imperfections, to offer a basis for reconciliation of these contradictory theories. Sorokin distinguishes between a "Sensate" mentality, which accepts as truth only that which can be recognized by the senses and instruments which serve as their extensions, such as microscopes and telescopes, and an "Ideational" mentality, for which ultimate truth can only be derived from supernatural revelation or from intuition of the essences underlying external appearances. The "Idealistic" mentality is, at best, a "harmonious fusion" of Ideational and Sensate.

The fluctuations of these basic cultural orientations have left their traces in the surviving documents of all ages. Sorokin's most important work, *Social and Cultural Dynamics*, provides quantitative indicators of these fluctuations as they have occurred at the level of the "elite culture" in the most important European societies. It seems probable that these fluctuations in cultural mentality have in fact been more pronounced in the "cultural elites" and in the middle classes than in the peasantry or the urban proletariat. Therefore, if one is concerned with these fluctuations and their effects, one *must* study primarily the elite culture (which is, in any case, the only one for which an extensive continuous record is available), without, however, deluding oneself, as Sorokin has tended to do, that it represents corresponding movements in the minds of the "nonelite" classes. The hypothesis to be suggested in this chapter may, however, well be applicable to the creativity of folk artists in the literate civilizations, even though the factor conducive to artistic creativity may emerge in different historical periods for the urban elite and for the peasantry. This factor has been, apparently, least likely to develop among the urban proletariat.

To translate Sorokin's data into the theoretical terms of this book, it is postulated that periods of overwhelming and relatively unchanging dominance by either the Ideational or the Sensate conception of the nature of ultimate reality represent latency phases of a psychoideological phase cycle; that periods in which indicators of the previously suppressed kind of mentality are beginning to increase in frequency can be identified as the disturbance of latency; and that Idealistic periods, in which Ideational and Sensate

elements are most nearly comparable in prevalence, correspond to the goal-attainment phase. The integrative phase cannot always be clearly identified on the basis of Sorokin's data, but it should be characterized by greater strength of the ascending type of mentality than of the declining type, but not yet by an overwhelming dominance by the former. It is only in this stage, when the old type of mentality can be *absorbed* into the basic pattern of the new, that a fundamental restructuring of ideological motivation can take place.

It has already been assumed, in Chapter 6, that achievement and expressive drives, which are not by their very nature antagonistic to each other, are most likely to become integrated with each other when they are most similar in strength. But Ideational and Sensate orientations represent conceptions or perceptions of the nature of reality that are at least potentially mutually exclusive. They have tended to seem so to the culturally predominant type of Western mind, at least after the Middle Ages, but they have frequently appeared to be fused with each other to non-Westerners (as well as to some Westerners). Depending on the prevalence of synthetic (fusing) or analytic (isolating) attitudes toward reality, Idealistic periods may either represent a harmonious fusion of the Ideational and the Sensate perceptions of it or generate the most intense equilibrium-disturbing impulses in the personality system. The latter seems more likely to occur in the West and perhaps in the modernizing societies generally, and it may occur at a less conscious level of motivation even when a harmonious fusion appears to be established in the public ideology. This is the reason for identifying Idealistic pe-

riods—at the very least in societies of the modern Western type—with the goal-attainment phase of the psychoideological cycle.

The culture-mentality cycle is a sequence of slow pervasive changes in fundamental orientation toward reality. It is analytically differentiated from the generally shorter ideological-action cycles considered in Chapter 4. However, an absence of effective challenge to established religious or secular ideological orientation—which may be subjectively experienced as boredom with ideological issues—is common to periods regarded as those of latency in both types of cycles. The challenge begins to be felt in the disturbance-of-latency phase. After a period in which we would assume that the challenge would be most intensely experienced, the goal-attainment phase, the necessity to integrate old orientations with the new attains temporary primacy in both types of cycles. The operative factors responsible for each type of cycle are different, and the interrelations between the two cyclical movements are likely to be historically complex. It is nevertheless assumed that the phase-cycle theory is applicable, with appropriate modifications, to both of them. That is, artistic creativity can be expected to increase in the goal-attainment and integrative phases of the psychoideological cycle, and to decline in the phases of either Ideational or Sensate latency.

SOROKIN'S EVIDENCE

When quantitative indices are used, a particular phase of the culture-mentality cycle may have to be somewhat differently delineated in different spheres of action. Insofar as the environment of artistic creativity is concerned, two

of Sorokin's content indicators may be employed for this purpose: (1) the relative frequency of religious as compared with secular subject matter in art and (2) the percentages of art works that are of a "spiritual" as compared with a "sensual" character. A stylistic index combines the percentages of "naturalistic" and "impressionistic" works of art into a measure of Sensate mentality and adds up the frequencies of "formal" and "expressionistic" works, thus deriving a measure of Ideational mentality.

An additional category of "mixed" styles may perhaps be regarded as indicative of an Idealistic mentality. Periods in which the mixed style is, according to Sorokin's analysis, most frequent (1350–1450 in Italy, the fifteenth and sixteenth centuries in Spain, 1500–1650 in France, the sixteenth and seventeenth centuries in England, and the seventeenth century in Russia) tend to coincide with the periods in which identifiably different Ideational and Sensate styles are most comparably prevalent. This correlation suggests that the Idealistic mentality appears *concurrently* in two forms: in one the Sensate and the Ideational are harmoniously fused; in the other they are in conflict. Idealistic periods overlap with periods of peak artistic creativity in Italy, precede such peaks in Spain, England, and perhaps France, while no relationship is evident in Russia. Thus, stylistic indicators of an Idealistic mentality in the environment in which art is created and used do not provide a guarantee of artistic efflorescence.

A predominance of the harmonious fusion possibly indicated by the mixed style is, however, associated with the peak, in the twelfth through the fifteenth centuries, of a specifically religious tradition of art—the medieval Chris-

tian, which cannot be classified according to "national" adherence. In contrast to the apparent independence of the later national artistic peaks from Ideational orientations, the earlier European church art seems to have benefited from a harmonious fusion of Ideational and Sensate mentalities. If this is so, the hypothesis arises that the potentiality for artistic creativity within a religious tradition emerges from the *fusion* of culture mentalities, and within a secular tradition, at least in part from the experience of the *breakdown* of this fusion. In the rest of this chapter, Sorokin's data on art styles and content will be analyzed for each European nation separately; the mixed styles will be disregarded.[2]

If the index of religious versus secular content is applied to the Netherlands, a disturbance of Ideational latency seems to be indicated for some period before 1500 and may help explain the flowering of Flemish fifteenth-century art. An Idealistic goal-attainment phase is indicated for 1500–1600. This was, however, a period of religious reformation and struggle for national independence, both of which are likely to reduce artistic creativity. An artistic efflorescence occurred immediately after the end of the "time of troubles," in what seems to have been an integrative phase of the psychoideological cycle. Both content indicators agree in defining the post-1660 period as a time of clear Sensate latency, and an artistic decline did in fact occur (Rembrandt died in 1669). The stylistic index shows no variation over time (from before 1500 to 1800, the styles were predominantly Sensate) and consequently cannot be used to predict variations in artistic creativity.

In England, the cycle appears to have occurred a little

later. The disturbance of latency is indicated by both content indicators in or before the sixteenth century, and the goal-attainment phase is suggested in the seventeenth century. The latter was likewise a period of politico-religious revolution, and an artistic peak, in painting, occurred some fifty years after its termination. Since at that time the Ideational element was rapidly declining after an Idealistic century, the *beginning* of the eighteenth-century efflorescence must be regarded as having occurred in an integrative phase of this cycle. The stylistic index suggests a goal-attainment phase in the sixteenth century. All three indices identify the eighteenth century as the phase of Sensate latency, in which artistic creativity should have been reduced. Actually, this was a period of artistic efflorescence, possibly because it was a favorable phase of several other types of cycles, especially the communal and the economic. (Also, there were challenges to the Sensate mentality, represented by Methodism, which did not register in Sorokin's artistic indicators, since the Methodists were not engaged in producing visual art.) The decline in art was postponed until the nineteenth century. Thus, for particular nations the predictions of artistic creativity on the basis of culture-mentality cycles must be corrected by reference to other types of cyclical movements.

In Spain, the religious versus secular content indicator locates the goal-attainment phase in the seventeenth century. The spiritual versus sensual content indicator does not permit this phase to be identified. The stylistic index locates it in the fifteenth century. The peak of Spanish artistic creativity can probably be placed in the second half of the sixteenth and the first half of the seventeenth

centuries, with the integrative phase indicated by the stylistic index, the goal-attainment phase by the religious versus secular content indicator. The sixteenth century was also a period of *communal* integration following national consolidation, and the effects of this process on artistic creativity can hardly be separated from those of the culture-mentality cycle. Most probably the two types of processes re-enforced each other in producing an artistically favorable epoch. All indices point to a Sensate latency in the eighteenth century, when artistic creativity declined.

In France, the stylistic index indicates an Idealistic goal-attainment phase for 1500–1600. Content indicators suggest a disturbance of Ideational latency before 1500, and a goal-attainment phase from 1600 to 1650. The latter period partly coincides with what Sorokin has identified as one of the best periods of French painting, 1620–1670—even though, as is noted in Chapter 2, above, French painters did a major part of their work in Rome, and it might therefore not be regarded as primarily French. All indices agree in correctly predicting an artistic decline, in a period of Sensate latency, from 1650 to 1800. Most of this period (1650–1750) has been identified as an integrative phase in the communal cycle (Chapter 5). This should have stimulated artistic creativity, and to some extent may have done so, in the rococo period. But the adverse effects of latency in the culture-mentality cycle may have partly offset the positive effects of integrative processes in the cycle of communal action.

The longest time series are available for Italy and Russia. In Italy, a disturbance of Ideational latency is suggested by both sets of content indicators for 1300–1350,

and it may in fact have had an artistically stimulating effect. The stylistic index indicates that this stage may have begun as early as 1200. The goal-attainment phase, identified by the stylistic index as 1200–1450, and by the religious versus secular content indicator as 1550–1700, in either case partly overlaps with the period Sorokin estimates as that of highest artistic attainment, 1420–1600 (1680).[3] The stylistic index, however, seems to be on the early, and the religious versus secular content indicator, on the late side in identifying the period of highest artistic creativity. The same is true of Sensate latency. According to the stylistic index, this phase is defined as 1450–1900, and according to the religious versus secular content indicator, it is clearly established only for 1850–1933. The first index is a century and a half too early in its predicting of the decline in creativity which did occur, and the second is definitely too late. According to the spiritual versus sensual content indicator, the Idealistic goal-attainment phase would be located only from 1700–1750, and Sensate dominance be established only from 1850–1933, which again seems unrealistically late. However, it is only in Italy that content indicators lag several centuries behind the stylistic index. One factor which may have delayed the conscious recognition, in the choice of subject matter, of subconsciously experienced changes in culture mentality, reflected in style, may have been the extensive production of church-related art.

In Russia, all three indices define the twelfth to the sixteenth centuries as a period of Ideational latency. It was followed, in the seventeenth century, by a disturbance phase, which was also linked with a political "time of trou-

bles" and, possibly for this reason, did not particularly stimulate artistic creativity. Sensate latency, in art-consuming circles, is indicated for the eighteenth century and until 1875. The spiritual versus sensual and the stylistic indices suggest a disturbance of this kind of latency after 1875, which was followed, after 1900, by the modern efflorescence of Russian painting.

The religious versus secular content indicator does not register, for any nation, a disturbance of Sensate latency in the twentieth century. The stylistic index of Ideationalism, however, shows an upward trend starting, in various nations, about 1875 (but 1825 in France and 1830 in Holland).[4] Since the spiritual versus sensual content indicator also suggests a disturbance of latency in approximately this period, Sorokin's data may provide a basis for explaining the modern revival of artistic creativity. Ideational tendencies are generally subordinated to the Sensate in the modern societies—though there is an increasing "postmodern" tendency among artists and educated youth to question the dominance of Sensate values without actually affirming Ideational ones. These tendencies may promote a state of tension in culture mentality apt to be artistically stimulating.

A detailed survey of the national series suggests that there is a reason for the inconsistencies among the several indices of culture mentality: the stylistic index generally defines all phases at earlier dates than do the content indicators. The former may measure changes occurring on a more subconscious level of culture mentality. They appear to be registered by the content indicators when, after a time lag (which was particularly long in Italy), the conscious mind becomes aware of them.

Sorokin's data indicate, then, that either Sensate or Ideational latency reduces artistic creativity and that disturbance of such latency tends to be artistically stimulating. The inconsistency between the stylistic and content indicators does not permit any clear conclusion about the relationship between artistic creativity and the goal-attainment and integrative phases of the culture-mentality cycle, although both phases seem to be, in a general way, artistically stimulating. If the content indicators are used, artistic efflorescences appear to have occurred in the integrative phase of the culture-mentality cycle in Holland and England, and in the goal-attainment phase in Spain and France. Stylistic indicators do not account for artistic efflorescence in Holland and England; they suggest an association of creativity with an integrative phase in Spain and France. Both types of indices are equally valid for Russia and dubious for Italy.

On balance, the content indicators seem to be more predictive of artistic creativity than the stylistic indices. Art content has been interpreted as a reflection of behavioral roles, and style as an expression of more generalized emotional orientations.[5] If so, the apparently closer relationship of the content indicators to artistic creativity suggests that it may be the tension between secular and religious orientations *sensed at the behavioral rather than emotional level*—that is, more consciously experienced—that is most stimulating to artistic creativity. The most obvious failures of this index to be predictive of artistic efflorescences, such as that in seventeenth-century Russia, can be explained by the impingement of goal-attainment phases of ideological, communal, or political *action* cycles.

Thus it seems permissible, at least, to hypothesize that

in Europe, since the Middle Ages, artistic creativity has increased when the harmonious fusion between Ideational and Sensate mentalities (indicated by the frequency of Sorokin's mixed styles) was disintegrating and the resulting disharmony was being consciously perceived and reflected in art content. The limitations of the data available for this study do not permit a definitive test of this hypothesis, and, even if it should hold for Europe, it may or may not be valid for civilizations of a type different from the postmedieval Western.

In view of the immense historical complexities involved, the present analysis may be regarded as yielding a measure of support for the general theory that a balance—whether harmonious or conflictual—between Ideational and Sensate culture mentalities is conducive to artistic creativity. Sorokin's unquantified observations on ancient Greece [6] also tend to support it. And Kroeber has suggested that the most artistically creative periods in the usually strongly religious Buddhist cultures of the Far East have been those of reduced religious intensity.[7] While the Nara period in Japan was "an age of great religious faith," it was also, like the Renaissance in Europe and the T'ang era in China, an epoch "of material splendor, during which the interests of the people centered more and more upon the things of this world. In all three cultures it was likewise a time when the arts flourished, especially in the fields of sculpture and painting." [8] Conversely, intense Ideationalism provided the background of the ancient Judaic repudiation of visual art and for the iconoclastic tendencies in the early phases of diverse religions. There is thus some corroborative evidence from non-Western civilizations as well.

THEORETICAL OBSERVATIONS

The principal difference between the ideological-action and the culture-mentality cycles in relation to artistic creativity is the apparent absence of the negative effects of the goal-attainment phase in the culture-mentality cycle. While the goal-attainment phase of ideological cycles is a relatively short period of extreme commitment of resources to ideological action and of their diversion from artistically creative action, the corresponding phase of the culture-mentality cycle is a protracted period characterized by a powerful challenge to an old cultural mentality by a new one. The action which occurs as a response to this challenge is, in part, directed toward the inherently creative goal of reconciling the old with the new. The higher level of artistic creativity, which may be due to the activating effect on creative motivation of a disturbance of latency in the culture-mentality cycle, persists as long as this kind of motivation continues to be so activated, that is, until a new latency phase attains primacy in the sociocultural system.

In short, an equilibrium in culture mentality, characterized by unchallenged dominance by either a religious or a secular mentality, appears to reduce, and disturbance of equilibrium to increase, individual motivation (and hence, to some degree, the capacity) for artistically creative action. The need for artistic creativity in the motivational dynamics of the personality system appears to be enhanced by a degree of balance between religious and secular orientations in the cultural system, with neither sufficiently powerful overwhelmingly to dominate the other.[9]

Efforts at repression may indeed become temporarily

more intense in the goal-attainment and integrative phases of the psychoideological cycle, precisely because of the increased power of the challenge of the new to the old cultural elements.[10] But in this stage, such efforts are not likely to be successful. While they express and perhaps intensify the energy-activating cultural tensions inherent in such periods, they do not prevent an ongoing substantive transformation of culture from taking place. And the necessity to integrate, when repression has become impossible, the old with "a new culture and a new dramatic material" [11] seems to generate a particularly intense need for great art. This need could be accounted for in part by the capacity of such art to reconcile the logically incompatible—sense perceptions and faith—and in part by its ability to give focus to what might otherwise become, in a period of cultural transformation, disoriented emotions.

The empirical evidence cited in this chapter does not particularly support the idea that "the aesthetic dimension" reconciles "sensuousness and intellect, pleasure and reason." [12] If the integrative task of the aesthetic arises at the meeting point between sense perceptions and *faith,* a deficiency in one or the other of these orientations in a cultural tradition and the impoverishment of either the sense perceptions or faith would reduce the possibilities of high artistic attainment. Art would then be incapable of performing one of its essential sociocultural functions.

If art is most potent when empiricism and faith are most equally balanced—whether in harmony or in tension—art can be viewed as a device for linking perceptions of the senses with ultimate commitments. But perhaps, especially in industrial societies, the Ideational should not be con-

ceived mainly as a supernaturalistic faith, but rather as the "metaphoric" conception of reality—all symbolic structures transcending sense impressions, whatever their specific character.

8. Sex Norms, Emotionality, and Artistic Creativity

The psychoanalytic theories which have linked artistic creativity to a partial "sublimation of instinctual drives" (or their displacement), combined with "a certain amount of direct sexual gratification," [1] suggest that artistic creativity may be enhanced in the historic periods characterized by a moderate inhibition of sexuality, and reduced in those of either extreme sex restrictiveness or permissiveness.[2] Psychoanalytic theory also relates emotionality—a "richness and intensity of feeling" [3]—to the ability to create art. And experimental psychology has shown originality to be associated with "responsiveness to impulse and emotion" and a "greater depth of feeling." [4] It stands to reason that emotionality is not a free-floating quality, but, rather, is, to varying degrees, attached to man's relationships with sociocultural objects and expressed through them. We might, then, expect the historic periods in which the investment of feeling in sociocultural objects is high to be the artistically creative ones.

Since the emotionalization of sociocultural objects may be related to socially imposed or internalized inhibitions

of direct sexual gratification,[5] I start with the hypothesis that the two variables presumably linked with artistic creativity—moderate sex restrictiveness and emotionalization of culture and social relations—will also be associated with each other. The initial hypothesis is that moderate restrictiveness (whether moderate in principle or extreme in theory but only partly effective in fact) increases the chances that men's potential for emotional responsiveness will be neither suppressed by ascetic discipline nor prevented from developing by the habit of immediately satisfying impulses. The more highly developed men's emotional capacities, the more investment of emotion in sociocultural objects may be expected. Moderate restrictiveness should thus promote creativity in visual art by providing a psychological element, emotionality, required in art by virtue of its character as a system of expressive symbolism. Extremely strict or permissive sex norms are hypothesized to have a de-emotionalizing and, consequently, artistically inhibiting effect.*

A CROSS-CULTURAL NOTE

A cross-cultural comparison, however, immediately suggests a few modifications of the hypothesis. First of all, a distinction between the investment of emotion in cultural and in social objects is evidently needed. A feeling orienta-

* In this chapter, restrictiveness refers to the effective limitation of sexual behavior to monogamous marriage, and permissiveness to the absence of restrictions, other than the incest taboo, on the sexual behavior of either sex. These are to be viewed as extreme positions on a continuum of restrictiveness-permissiveness, and represent policies actually put into effect by societies (or groups within them) rather than merely individual attitudes. The most extreme policy, prohibition of all sexual activity, can be institutionalized only for select groups but not for whole societies.

tion has been built into the *cultural* systems of most of the historic civilizations except the Chinese and the Western, which has de-emotionalized culture, particularly in the Roman tradition, and has exhibited fluctuating cycles of emotionality and rationality since the Middle Ages.[6] The cultural tradition was "emotionalized" in India, though sexual norms seem to have been somewhat more permissive in social practice than those of "rationalistic" Confucian China. However, a strong sense of tension between asceticism and eroticism—both fully legitimated cultural themes—was present in the Indian religious ideology [7] and absent in the Chinese. This tension may help to account for the emotionality in Indian culture. The Chinese-Indian comparison suggests that the degree to which cultural systems, such as religion, are pervaded by feeling is not, in any simple linear manner, dependent on sexual restrictiveness.

The emotionalization of *social relations,* especially between the sexes, as in "romantic love," may be more closely associated with sexual restrictiveness. As one compares the cross-cultural abundance of feeling-oriented religions with the rarity of romantic love as the standard for relations between the sexes,[8] a carry-over of emotionality from culture to social relations seems less than inevitable. An intense emotionalization of religion may indeed *reduce* the feeling for people, as emotional energies become totally committed to symbolic objects. This may have happened in the Aztec civilization. Conversely, a de-emotionalization (e.g., in highly bureaucratized societies) of social relations may cause a compensatory demand for intensely emotional cultural systems.[9] Such discrepancies indicate that culture and

social relations are not necessarily, in any given sociohistorical situation, emotionalized to the same degree.

As the comparatively rationalistic yet artistically creative civilization of historic China indicates, the relationship between emotionalization of the sociocultural universe and artistic creativity may also be more complex than was originally visualized. At the very least, it should be clear that, in the long run, a fairly rationalistic civilization does not preclude artistic attainments of the highest order. The immediate effects of a rationalization of culture might seem to be adverse to art; the development of the "rationalistic system" in the second half of the seventeenth century in Western Europe coincided with the decline in artistic creativity during this period. The decline, however, occurred also in the countries not greatly affected by the scientific spirit, such as Spain. Furthermore, "rationalism" was not nearly as predominant among the European "systems of truth" during this period, according to Sorokin, as it was in classical Greece during the sixth and fifth centuries b.c., the peak of Greek artistic creativity.[10] Thus, the dominance of rationalistic philosophies among the intellectuals of a period does not necessarily detract from its artistic creativity. The artists of classical Greece, however, had ancient mythologies as well as contemporary philosophies to stimulate their imagination.

Although cultural rationalization does not preclude artistic creativity, the most intense cultural emotionalization appears *not* to be most favorable to creativity in visual art. Artistic peaks tend to follow or precede those of popular mysticism. Sorokin has found that mysticism had the greatest influence among the European systems of truth from

the second to the fifth, and during the twelfth and the fifteenth centuries. Artistic efflorescences followed the first two periods and overlapped with the third (in Flanders). But even in the last case, an artistic climax followed a prolonged growth of religious mysticism. In Greece, on the other hand, the rise of philosophical mysticism, in the fourth century B.C., preceded a declining trend in visual art. But this was a relatively small wave of mysticism in an atmosphere that continued, at least among the intellectual elite, to be dominated by rationalism and skepticism,[11] and might have been insufficient to stimulate the visual imagination, as popular movements of *religious* mysticism have on several historically important occasions.

CYCLES OF SEXUAL CONTROL

Attempts to analyze the dynamic interrelations between sex norms, emotionality, and artistic creativity have led to the hypothetical conception of a historical cycle of sexual control, comparable to the two other psychohistorical cycles previously identified (Chapters 6 and 7). The cycle begins when a society is in a condition in which impulses likely to upset a quiescent state of the personality system are least likely to originate in its subsystem of sexual motivation. This condition may be identified as an approximation to a highly permissive sociosexual *latency*. I would expect this phase to generate a sense of "boredom" in the motivational system concerned—in the present case, an indifferent, matter-of-fact attitude toward heterosexual behavior.

When impulses upsetting the equilibrium of the personality begin increasingly to originate in the system of sexual

motivation, we have a disturbance of permissive latency. It can be disturbed either by "mechanical" distortions of the sex ratio in a monogamous population or by "moralistic" demands for more restrictive sex norms.* Such demands tend to appear in periods of an increased sense of social threat or as reactions to the "extreme luxury of the great cities" [12] coupled with the sexual permissiveness and emotional indifference to people that luxury appears to promote, as in Rome during the first and second centuries A.D., the later Renaissance, and the first half of the eighteenth century.[13]

It may in fact not be the luxury but the permissiveness that promotes emotional indifference, since the latter characteristic is also frequently found in impoverished, low-status groups with highly permissive sex norms,[14] and appears to be one of the generic characteristics of the "culture of poverty." [15] This emotional indifference may be limited to social relations and not extend to cultural orientations. The Babylonian Astarte cult reveals the permissiveness-unemotionality relationship. However, while the "social" *practice* of the cult, involving the young women in the

* A conceivable third way in which permissive latency of the sexual-control cycle can be disturbed might be a large-scale inhibition of the heterosexual interests in favor of the homosexual. Insofar as this trend would conflict with the "more natural" tendencies of the organism (even where it does not conflict with social demands) or, more probably, produce severe pressures in cross-sex, parent-child, and communal social relationships (Philip E. Slater, *The Glory of Hera: Greek Mythology and the Greek Family* [Boston: Beacon Press, 1968]), it may provide a built-in source of disturbance of quiescent states of the personality system. This should promote an emotionalization of culture or of social relations (within the same sex), which in turn might favor either artistic creativity, as in classical Athens, or an irrational cult of militarism, as in Sparta and, to a considerable degree, in Athens as well.

temples and the strangers who chose them for ritualized
sexual relations, was impersonally unemotional, the "cul-
tural" *myths* of the cult, the stories about Astarte's love
for Tammuz, were intensely, Dionysiacally emotional.[16]
Perhaps both extremes of economic status, poverty and
wealth, as well as of sex norms, restrictiveness and permis-
siveness, tend to accompany a reduced emotional respon-
siveness in social relations.

The period in which the moralistic demands for restric-
tive norms are being institutionalized in a society is con-
ceived of as the *goal-attainment* phase of the sexual control
cycle (the third and fourth centuries A.D. in Rome,[17] per-
haps the late eleventh and the twelfth centuries in Europe,
and the sixteenth century). In this period, equilibrium-
upsetting impulses are more likely than before or after-
ward to originate in the personality's system of sexual
motivation, and extremely distressing tensions to be experi-
enced within that system. The distress arises not only from
the imposition of more severe norms, but also possibly from
an increase in the intensity of sexual motivation that may
be an unintended consequence of the more restrictive
norms.[18]

The restrictive norms are likely to be subsequently mel-
lowed ("humanized") in what is conceived of as the *inte-
grative* phase of the sexual-control cycle, when sexual moti-
vation becomes permeable to, and articulated with, other
elements of the personality system, thus helping to stabilize
it. In this phase, compromises between the restrictive stand-
ard and what is perceived as the demands of "human na-
ture" come to be regarded as necessary and not excessively
disturbing—as happened in the fifth through the eighth

centuries in most parts of Christian Europe, a period when "the world grew accustomed to a dangerous alternation of extreme asceticism and gross vice." [19] During this period, in the fifth and sixth centuries, "the flowering of the Christian art of Antiquity" occurred.[20] Another example of this phase seems to be the period from the thirteenth to the fifteenth century in Europe. The cycle, unless it is disturbed again before completing itself, may end with a return to the latency phase.

There is some evidence indicating that permissive latency is consistent with an emotionalization of cultural orientations (as was the case in Hellenistic and Roman Greece and Rome after the second century A.D.). Perhaps the emotionalization of cultural orientations that has occurred in some permissive periods prepares the ground for a subsequent disturbance of permissive latency in the sphere of sexual norms. The spread of the Oriental mystery religions in imperial Rome certainly facilitated the introduction of ascetic Christianity.

In a *clearly defined* goal-attainment phase of the sexual-control cycle, it seems likely that only the cultural system, but not social relations, could be invested with a great deal of emotion. (Social relations cannot be emotionalized in this phase, because they tend to become subordinated to the abstractions of the "moralistic" goal.) In Christian Rome, the cultural system of religious beliefs became intensely emotionalized with the introduction of restrictive sex norms, while the relations of the most ascetic Christians, the hermits, to other people tended to become permeated with an indifference no less extreme than that exhibited by some of the libertines of the pagan Empire.[21]

In the general population, however, which did not devote itself to such extreme asceticism, early Christianity probably increased the sensitivity to physical suffering (evident in the development of charity and in the outlawing of gladiatorial combats) and, in this sense, promoted a diffuse investment of feeling in social relations.

These comparisons offer some support for the hypothesis that the extremes of both restrictiveness and permissiveness tend to de-emotionalize ordinary *social relations,* though they may both promote the investment of feeling in the abstractions of culture, such as religious images or philosophical concepts. In the Roman Empire, permissiveness had no immediate adverse effect on artistic creativity, while restrictiveness probably did (in spite of the emotionalization of culture which it helped to institutionalize). Early Rome is another case in which relative unemotionality in social relations accompanied restrictiveness and a lack of artistic creativity.

In each instance from postclassical Western history reviewed in the following section, the relationships between sex norms, emotionality, and artistic creativity are complex in a somewhat different way, but they appear to be in accord with the model of the phase cycle of sexual control that has been proposed.

SOCIOSEXUAL DYNAMICS IN THE POSTCLASSICAL WEST

The investment of emotion in social relations between the sexes—or perhaps only in the attitudes of the poets and their audiences toward such relations [22]—in medieval Europe seems to have increased considerably with the emergence of the "courtly love complex . . . in Muslim Spain

in the eleventh century, in southwestern France in the twelfth century, and in southern Germany in the later twelfth and thirteenth centuries." Moller has held that a "high sex ratio owing to the masculinization" of the aristocratic population of the castles, "through sex-selective immigration," was partly responsible for the rise of the courtly love complex.[23] The opposite process of out-migration, resulting in a low sex ratio and a feminization of the population, he regards as a factor in the rise of affective mysticism, from the twelfth to the eighteenth centuries, in other parts of Europe.[24] However, this emotionalization of attitudes toward social relations, in the aristocracy, and toward religion, in the urban population, occurred after the only partially successful attempts of the Church to strengthen the family institution and impose a stricter conception of sexual morality (the Cluniac and Hildebrandine reforms during the tenth and eleventh centuries, which produced "a fierce fanaticism of asceticism" in the parishes).[25] The rise of the courtly love in France coincided, furthermore, both in time and space, with the ascetic popular heresy of the Cathari.[26]

Whether in this case the emotionalization of the sociocultural universe was due to religiously imposed restrictive norms or to the unplanned development of distortions in the sex ratios, it seems to be linked with increasing inhibitions of direct sexual gratification. An artistic revival, nevertheless, took place during this period, as it did not under the influence of Christian asceticism in Rome. In medieval Europe, however, the ascetic wave occurred as a reform movement within a well-established and prosperous religious organization [27] rather than during

the establishment of a new religion. The former process may be more favorable to artistic creativity than the latter. The medieval wave of asceticism, furthermore, coincided with a period of political consolidations and expansions as well as a revival of trade. The social dynamism could have countered whatever inhibiting effects asceticism by itself might have had on the artistic imagination. Finally, during the transition from the Romanesque to the Gothic, an emotionalization, at least at the symbolic level, of social relations (indicated by the myth of courtly love) was apparently also taking place—another influence, missing in ancient Rome, that may have been favorable to artistic creativity.

Neither the movement of affective mysticism (except for St. Francis) nor the emotionally intense courtly love complex (as contrasted with the polished etiquette of the sixteenth-century courtier) was ever prominent in Italy. The beginning of the Renaissance is associated with a trend toward permissiveness in sex norms which is said to have started, in Italy, in the thirteenth century [28]—just before the period of Giotto and Dante. This trend continued, in Italy, until the sixteenth century, a period of extreme (for Christian Europe) [29] sexual permissiveness and of ruthless indifference to people—as well as of incipient economic decline. None of this, however, seems to have had an adverse effect on artistic creativity, perhaps because the period continued to be characterized by an approximate balance between religious and secular orientations.[30] Such a balance seems to be more closely related to artistic creativity than any particular type of sex norm. In spite of Savonarola and the Counter Reformation, the Renaissance-baroque period was relatively permissive in

Italy, so far as the art-consuming circles were concerned; and though this period started with an infusion of more feeling into social relations and cultural products, further advances in emotionality do not seem to have been made. Only the beginning of the Renaissance, but not its flowering, might be explained by the hypothesis of emotionalization, and the latter seems to have occurred when the strictness of sex norms in art-using circles was beginning to diminish, after the peak of sexual restrictiveness.

The restrictive reaction of the Reformation may be regarded as least influential in the countries in which a large-scale Protestant movement did not develop and which had a restrictive tradition to begin with—thus, in Spain. The Counter Reformation, however, re-enforced the restrictive attitude toward sexuality in Spain. Furthermore, the out-migration of young males from sixteenth-century imperial Spain produced a low sex ratio, a feminization of the population. Consequently, in accordance with Moller's demographic interpretation of affective mysticism, "in the sixteenth century, Spain produced the most magnificent literature of this genre in European history." [31] In the seventeenth century, "Spanish mysticism became stereotyped and lost its creative force." [32] "The decline of Spanish mysticism synchronised with the decline of Spain itself" [33]—indicating that mysticism does not necessarily arise as a compensation for social decadence. Once again, as in the twelfth and thirteenth centuries, one finds an emotionalization of culture associated with—in this case slightly prior to—the peak of artistic creativity (estimated as 1580–1660) and linked with increasing inhibitions of direct sexual gratification.

In the nations in which the Protestant Reformation took

place on a large scale, artistic creativity was reduced at the time the Reformation was occurring most intensively—in Germany and the Netherlands in the sixteenth century, in Great Britain in the seventeenth. The chief reason for the declines was probably the diversion of social resources to religious and religio-political action. Nevertheless, these were also periods in which attempts were made to institutionalize more restrictive sex norms for the general population and in which "romantic love" was beginning to be integrated into the marriage relationship. In both the Netherlands and England, artistic creativity revived within a century after the Reformation. The Dutch artistic efflorescence of the first half of the seventeenth century occurred in a culture with generally strict middle-class sexual standards, and the emotionalization of culture indicated by a wave of affective mysticism took place only "in the early seventeenth century," [34] when the artistic efflorescence was already in full bloom. The Dutch case suggests that artistic efflorescences can occur in periods of restrictive sexual standards, if these are not currently being introduced and can therefore be psychologically "taken for granted." (In contrast, religious or secular ideological orientations appear to be most artistically stimulating when they *cannot* be taken for granted.) [35] In Germany, artistic creativity did not revive in the post-Reformation period: the losses of population and the physical destruction caused by the religious wars of the seventeenth century precluded high artistic attainment for another century. The artistic revival in the eighteenth century was preceded by an emotionalization of German religious culture, brought about by Pietism.

In England the period of the artistic revival—the first half of the eighteenth century—was characterized by extreme permissiveness in large circles of the aristocracy and by rather strict standards in the middle class. The latter was now, for the first time, becoming involved with art on a major scale and Hogarth created the bulk of his work for it. Society as a whole was not dominated either by strict or by permissive sex norms but was characterized by a tension between the two extremes. The period of sexual restrictiveness which is somewhat incorrectly identified with the Victorian age appears actually to have started with the founding of the second Society for the Reformation of Morals, in 1757—significantly enough, also the year in which "romantic" was first favorably used in literature.[36] While "the rationalists" of the first half of the eighteenth century "had repressed their emotions and acted out their sexuality, the romantics," in the second half of the century, "restrained their sexuality and poured forth their emotions." [37] In the earlier period, permissiveness was associated not only with emotional indifference in social relations (as in the later Roman Empire), but also with a de-emotionalized culture. The emotionalization of culture and of social relations among the consumers of romantic literature may have occurred later as a reaction to the lack of affectivity in the earlier period. The aristocracy was influenced by these restrictive trends only in the first half of the nineteenth century, with the institutionalization of what has been called "the Respectable Social System." [38] By 1850, however, a trend toward permissiveness was again evident,[39] though it seems to have been temporarily reversed in the seventies.[40] It was in the period of severe

but diminishing sexual restrictiveness that romantic love seems to have been most exalted.[41] Sorokin estimates that the most artistically creative period ended in 1850.[42] Thus an artistic peak continued through a period of increasing sexual restrictiveness. But the later trend toward sexual permissiveness, precisely in the social strata interested in art, did not increase creativity in visual art. Nor did the growing emotionalization of social relations. A powerful undercurrent of sensuality remained prevalent throughout this whole period, as it did in some other presumably "repressive" yet artistically creative periods, such as the twelfth century.[43]

In the United States, the modern trend toward permissiveness was most rapid during the 1920's.[44] America's artistic coming of age, with abstract expressionism, followed two decades later. The forties were a period of sensuality that emerged in reaction to an older yet still potent restrictiveness, as was perhaps the case also in the thirteenth century. More recently, however—especially perhaps in the 1960's—trends toward the de-emotionalization of social relations have become evident.[45] The de-emotionalization trends may to some extent be supported by further increases in permissiveness. However, some of the highly emotionalized groups of youthful rebels have been in the very forefront of the permissive movement, and their emotionality cannot be explained by a hypothesis that assumes permissiveness to be de-emotionalizing. Perhaps the hypothesis holds only for concrete social relations, and not for general cultural orientations; and, as in Restoration England (and perhaps in Tantric Buddhism),[46] a lack of affectivity in personal relations may be masked by a cult of

sensuality,[47] a kind of "abstract eroticism."[48] The emotionalization of culture may be a *reaction* to a de-emotionalization of social relations. But it seems that only a *moderate* emotionalization of culture can encourage the infusion of feeling into social relations.

SUGGESTED PATTERNS

The relations between artistic creativity and fluctuations in sex norms are exceedingly difficult to trace, partly because changes in the severity of norms cannot always be exactly located in time, the degree of change that really occurs cannot be rigorously measured, and, in complex societies, the trends affect some social strata or groups but not others (in which, in fact, the opposite trend may be occurring, as in England during the Methodist movement). Furthermore, emotionality is affected by variables other than sexual control,[49] and artistic creativity by variables other than emotionality.

An impression that can be derived from this survey is that a high level of artistic creativity can coexist with a considerable diversity of sex norms. Nevertheless, efflorescences of visual art seem unlikely to start in periods in which sexual restrictiveness is being institutionalized for the whole population of art consumers, as during the Christianization of the Roman Empire and during the Reformation. Artistic creativity seems to be enhanced by an emotionalization of social relations or of attitudes toward social relations that is more likely to occur when sex norms are of intermediate severity—whether the severity is increasing or diminishing over time.

The degree to which the ideological systems of culture

are "feeling-oriented" rather than "rationalistic" does not seem to be clearly related to variations in sex norms. The only discernible pattern is a tendency for cultural systems to become either extremely feeling-oriented or extremely rationalistic when sex norms are either highly restrictive or highly permissive; under either set of sexual standards, a "sensible" balance, in the cultural tradition, between rational control and emotional spontaneity seems rather unlikely. But this pattern is suggested only as a possibility. It seems probable that when social relations are highly formalized and emotionally restrained, the ability to create art is increased by an emotionalization of culture. This may have been one reason for the stimulating effects of Buddhism and Taoism on Chinese art, possibly for the similar effects of mysticism in Spain.

There is, in European history, no entirely convincing evidence of a reduction of artistic creativity during periods of sexual permissiveness. The best example of such a permissive period is perhaps 1450–1650 in aristocratic Italy. The ancient Roman artistic efflorescence, 30 B.C.–A.D. 110, also occurred in a sexually permissive period.[50] So did the artistic climax of Greece, 559–300 B.C.; [51] permissiveness, however, appears to have increased further in the following period, usually regarded as one of artistic decline. Berlew's study of references to impulse control in several kinds of Greek literary sources reveals approximately the same high number of references in the works written between 900 and 362 B.C., and a sharp reduction in those written between 362 and 100 B.C.[52] But in a cross-cultural perspective, even the most permissive periods in Europe seem not to have been "extreme," since restrictive standards were us-

ually upheld by some groups and some authorities,[53] and in fact internalized by large sections of the population. Thus the effect on artistic creativity of extreme sexual permissiveness cannot be effectively studied in the Western historical record.

Of the preliterate societies with the most permissive norms, in which "there seems to be little if any bar to any sort of nonincestuous activity"—societies such as the Baiga, Lesu, Marquesas, Toda, Kaingáng, Dieri, Gilyak, Hidatsa, Masai, and Yapese [54]—none is outstanding in its artistic attainments, and only the Marquesas create art of remarkable quality. While this is a static comparison (and its applicability to the historic civilizations has not been established), it nevertheless suggests that the latency phase of the cycle of sexual control—a phase characterized by extreme permissiveness—would be more likely than not to have artistically inhibiting effects in the historic and industrial civilizations as well. Thus both the latency and goal-attainment phases, in their extreme form, appear to be less favorable, and some kind of an "integrative" tension between restrictive and sensual tendencies in a social system more favorable, to creativity in the visual arts.

Artistic creativity does not seem to arise from unconstrained instinctual spontaneity or as a compensation for the complete repression of instinctual strivings. Rather, it appears to be, to some degree, the product of a tension, even a conflict, between spontaneity and repression, and would presumably be adversely affected by the absence of such a tension. If "art struggles against repressive reason and the reality-principle in an effort to regain lost liberties," [55] the absence of either the need for this struggle or

of the vigorous, undefeated desire to wage it may mean a diminution of the capacity to create art.

A recent institutionalization of highly restrictive sexual standards, however, seems to produce such an anxious and self-conscious preoccupation with asceticism that aesthetic desensitization is likely to occur. It is not the most intense but a moderate, somewhat relaxed, "taken-for-granted" tension between sensuousness and asceticism that seems to do most for the creation of art.

III. A GENERAL THEORY

9. The Phase-Cycle Theory of Artistic Creativity

A sociological theory derived from experiments with problem-solving in small groups has been used to conceptualize four types of social-action cycles occurring on a historical scale and applied to three types of psychohistorical, or motivational, cycles. The tentatively indicated effects of these cycles on artistic creativity will be briefly summarized here, and some possible further theoretical developments indicated.

ACTION CYCLES

A general pattern emerges from the analysis of historical processes occurring within the polity, the economy, and the communal and ideological subsystems of the society. In each of the four types of social processes, artistic creativity tends to be stimulated by a disturbance of a condition of relative equilibrium; reduced during the period of intense goal-directed action; increased during the normally following integrative phase, when the social system is settling down to a new equilibrium; and again reduced when the new equilibrium is taken for granted. The state of equi-

librium is one which is accepted as either "natural" (that is, unchangeable) or "legitimate" (corresponding to established expectations). Such acceptance may result from exhaustion and resignation to failure, when unsatisfactory circumstances appear to be beyond the possibility of change, or from complacency accompanying success.[1] In either case, a state of relative equilibrium is unchallenging and liable to be experienced as boring.

To put it otherwise: economic transformations, warfare and political consolidations, communal reorganizations, and ideological reformations tend to have a long-range stimulating effect on the creation of artistic values. Scientific, religious, and general intellectual creativity may be affected by similar social processes in a similar manner. In a phase of low creativity a society may seek or unintendedly achieve revitalization through any one of these four types of social processes. In this respect, they are functionally interchangeable. Each seems to be capable of performing the function of generating creative energies.

The effect on artistic creativity of different types of phase cycles may not be equally strong, swift, or persistent. Thus the artistically stimulating effects of ideological transformations seem to appear more slowly than do those of some types of economic, political, and communal changes. The rapidity of these processes seems to have accelerated during the course of history—particularly from one stage of societal evolution to another.

Artistic creativity is most likely to be influenced by those social processes which affect the producers and consumers of art, who may not be the entire population of a complex society. Social processes in art-consuming strata may not be

synchronized with processes occurring among groups in the same society that do not use art. In a complex society, different types of art-using groups may find themselves in different phases of the same social-action or, even more probably, motivational cycle—in which case they will presumably prefer different styles of art. When this is the case, groups which are in the disturbance of latency or integrative phases should make the greatest contribution to artistic creativity, if they are interested in art.

In the integrative phases of economic-action cycles, the economic elites may be particularly important as patrons of art. In the corresponding phases of political and religious cycles, the patrons could well be the political and religious elites, respectively. In the same phases of communal cycles, artistic creation may be more generally supported, with various types of elites involved as sponsors. These hypotheses presuppose that the several types of elites are differentiated from each other, capable of independent action, in possession of the relevant resources, and not prevented by their institutionalized ideologies from sponsoring art. The last two conditions in particular explain why the Protestant churches failed to provide any significant patronage to art during the Dutch and English artistic efflorescences which started in the century after the Reformation and the Puritan revolution, respectively.

In accounting for the observed relationship between social dynamics and artistic creativity, two basic variables have been distinguished. One is a hypothesized *social need for art*. Art may be conceived of as one of the symbolic factors which promote the integration of social experiences and cultural symbols with private emotions. When a

state of relative equilibrium in the social system is disturbed, private emotions tend to become disconnected from social conditions (including the technological environment) and cultural symbols, and art is more needed as a means of again bringing social conditions, cultural traditions, and individual emotions into a "meaningful" relationship with each other. Subjectively, this process may be experienced by the artists—as well as the users of art—as simultaneously a weakening of the constriction of their imaginations by traditional styles of art, which now cease to be emotionally convincing, and an increased sense of the existential significance of artistic activity.

The diffusion of an artistic tradition to another society or a revival of a past tradition of the same society frequently encourages creative growth, because diffusion or revival also weakens the hold of an established tradition on the imagination of artists or re-enforces a weakening that has occurred, for sociological reasons, before diffusion or revival is psychologically acceptable within the part of the society in which art is produced and consumed. Diffusion and revival also enlarge the supply of artistic models to work with. But an urgent social need for art is not generated either by diffusion or revival; hence these processes should not be sufficient by themselves to explain the artistically creative periods which follow diffusions or revivals.

Perhaps because they sense the reintegrative function of art, individuals who are uncomfortable with their society and cultural tradition tend to be more intensely interested in art than the socially well adjusted are.[2] Art is not the only cultural system to perform this function. Re-

ligion and ideology, and perhaps all cultural systems insofar as they are not of a purely "cognitive" or "normative" nature but contain "imaginative" elements, are involved in the process of reintegration of a sociocultural system after a disturbance of equilibrium and serve in part as resources for the particular human beings who actively participate in this process.[3] It is "imagination," wherever it is found, rather than "knowledge" or "norms," that articulates emotion with social structure.

For art creation to be possible, a second variable, *social resources,* must also be present.[4] To summarize what has been said earlier about social resources in relation to artistic creativity: During the phase of goal-oriented action within any type of phase cycle, resources are diverted from the creation of culture to direct social action. Hence, however great the need for art as an integrative factor during such periods, artistic creativity is reduced, owing to inadequate resource allocation.

In the integrative phase, the social need for art continues to be great, but resources become available for culture creation. For this reason, major artistic efflorescences are most likely to occur in this phase.

In the tension-reduction phase, resources for art creation may be even more plentiful, but the social system has become so stabilized that there is little need for art as an integrative factor. No sense of urgency attaches to artistic creation. Fantasy is reduced to fancy. Therefore, in the tension-reduction phase (as illustrated by the late Hellenistic period in Greece and the eighteenth century in Italy and Spain), a great amount of art may be produced, but its historical significance diminishes. An implication of

this analysis is that the level of artistic creativity may not be directly dependent on the quantity of the social resources allocated to art creation—not because the amount can be "excessive" in a manner injurious to quality, but because other elements essential for creativity may be missing in some periods which allocate great amounts of social resources to artistic activities.

The magnitude of the allocation of social resources to art creation, it would seem, determines the *amount,* and possibly the kinds, of art which will be produced. The social need for art affects the *quality* of the art produced (which is also influenced by the types of psychohistorical motivation discussed in the following section). By increasing the share of the gross national product devoted to artistic pursuits, a nation can create an art industry and a system of museums but not an artistic efflorescence.

Social resources, however, include not only wealth. Four types of social resources—that is, means for social action produced by society itself—may by distinguished: (1) wealth, (2) socially released time, (3) cultural symbolism—action-directing and life-defining concepts or models, and (4) the cathectic interests which a society or group attaches to an object or activity.

The temporal relationship between the production of social resources and their most effective use in art creation is variable. Socially released time and cathectic interests are "produced" and applied to art creation concurrently (though, as the problem of too much leisure or, on the other hand, of a lack of time for the pursuit of individual interests indicates, these two resources are not necessarily available to a comparable extent). Wealth—whether pri-

vate or societal—affects art creation some time after it has been accumulated. Cultural symbolism affects art most favorably when it has matured and become "intimately familiar," as Christian symbolism had in Europe by the Romanesque and Gothic ages. The time span between the production of a social resource and its most effective use in art creation seems to be longest in the case of cultural symbolism. The production of wealth and of cultural symbolism constitutes, from this point of view, a potential long-range investment in artistic creativity.

Among the social resources for artistic creation, cultural symbolism has a special status. The degree to which it, as well as cathectic interests, will be employed in art creation cannot be controlled by the dominant elites of the society. The dominant elites can neither decide to make effective cultural symbolism available in the society, nor, as the modern experience has shown, to make the most competent artists of the society inwardly accept the symbolism that is socially available. Two problems arise with respect to this social resource which do not with respect to the others: (1) What is the relationship between the creation of the metaphoric content of symbols and the creation of forms of expression of high aesthetic quality? (2) What is the effect of the psychological disposition of art creators to be fascinated, repelled, or left disinterested by particular types of symbolic content on the quality of their art?

Uncertainties about such matters reduce the capacity of the dominant elites to control the quality of art production in their societies and provide a structural basis for a strategic alliance between creative intellectuals of one period and creative artists, possibly of a later period—between

dead intellectuals and living artists. Living intellectuals do best when they serve as channels for informing the living artists of the symbolic creations of the past (or of other societies). Symbolic contents have to "age" before they can appeal to the artistic imagination by their *aesthetic*—that is, formal—rather than intrinsic qualities. This requirement may be reflected in Kroeber's observation that "it seems normally to be religion which first reaches its chief climax, and then the aesthetic and intellectual activities as they free themselves from religion." [5] When symbols are still fresh, attention tends to center on their intrinsic content or, possibly, their utility. Attention has to be liberated from a compulsive concern with the intrinsic content of things—material or symbolic—before it can fully respond to their aesthetic qualities.

In contrast to the creative intellectuals, or the myth makers, the critical intellectuals seem likely to have an adverse influence on artistic creation by transmitting to the artists their sense of alienation from myth, on which artists depend more than intellectuals do. Critical intellectuals, however, contribute to artistic creativity by generating a sense of discrepancy between social conditions and private emotions, but only when the discrepancy is not by itself sufficiently evident to everyone. (When it becomes generally apparent, the social demand for critical intellectuals declines, and that for social engineers or myth makers, or both, increases.)

In general, ideas seem to affect artistic creativity in two ways: either by stimulating or inhibiting the social or motivational phase-cycle processes which in turn influence artistic development, or by providing or failing to provide

the resources of cultural symbolism which artists could use. Any type of idea may affect artistic creativity in the first way but—it seems to me—purely cognitive ideas are less likely to affect art in the second way than "mythological," "metaphoric," cognitively affective ideas are. When it is believed that it is possible to say "everything," when there is an approximation to perfect rationality in the market of ideas or perhaps merely a lack of personal experiences that are not describable in a straightforward manner, high artistic attainment should be more difficult to sustain.

The social utility of art and resource-allocation patterns have not been empirically studied in this investigation, but rather hypothesized as mechanisms accounting for the relationships between social history and one kind of cultural growth that has been tentatively identified. A different set of intervening mechanisms is, in principle, conceivable. But it would have to provide a theoretical explanation of the patterns or tendencies inferred from the evidence presented.

The second explanatory variable, resource-allocation patterns, is, whenever the evidence has been recorded, accessible to empirical research, and they should influence the specific direction in which the presumably more general mobilization of creative imaginations will have to go. Resource-allocation patterns constitute a major area for testing the theory presented in this book.

It is likely that no one type of social resource is sufficient to make an artistic efflorescence possible. Indeed, the allocation of all types of resources may not be enough to cause the development of the highest peaks if a strong need

for re-integration in the social system and certain specific types of motivation in the personality system are absent.

MOTIVATIONAL CYCLES

Contrary to what a "vulgar materialist" might expect, artistic creativity is affected not only by social processes, but also by *motivational* variables partly independent of them. Artistic creativity tends to be stimulated in what has been conceived of as the disturbance of latency in the psychoeconomic and the psychoideological systems of motivation, and to decline when these systems are in their latency phase. In other words, artistic creativity tends to increase when balanced tensions exist between the motivation for achievement and the motivation for self-expression, on the one hand, and Ideational ("mythical") and Sensate ("empiricist") mentality on the other. Conversely, artistic creativity declines when achievement motivation is either extremely strong or extremely weak and when either Ideational or Sensate mentality is overwhelmingly dominant.

Artistic creativity seems, furthermore, to decline in a period in which highly restrictive sex norms are being institutionalized for art-consuming populations, in what may be regarded as a goal-attainment phase of the cycle of sexual control, and also in a period of extreme sexual permissiveness, the latency phase of this cycle. In contrast, moderate sexual restrictiveness or a state of tension between asceticism and eroticism, when both can be psychologically "taken for granted," may generate a kind of emotionality that contributes to creativity in visual art.

If these correlations between the motivational characteristics of a period and its artistic creativity have been validly

identified, it seems reasonable to suppose that highly crea-
tive artists, even in less creative periods, will be individ-
ually characterized by at least one, and possibly frequently
all three, of these types of tensions. It is not to be assumed
that these motivations within individual personalities de-
rive only from the long-term historical cycles. But such
motivations are likely to be most frequent, presumably, in
the appropriate phases of these cycles.

While these motivations may be characteristic of artists
as well as of the more interested art consumers during the
great periods of creativity, there is apparently no such
thing as a typical personality or a "timeless constitutional
type" of artist.[6] The motivational characteristics of the
environment of artists during creative efflorescences may be
more uniform than the total configuration of their own
personalities.

Artistic creativity (and perhaps all "imaginative" sys-
tems of culture) may be promoted by the psychological ne-
cessity to reconcile *all kinds* of contradictory motivations.
This need may provide the substance which the imagina-
tive capacity can work with. Without the need, the imagi-
native capacity may be limited to the choice between
"dogma" and "triviality"—to declaring dominant values
or expressing valuelessness, neither of which seems cre-
atively interesting. On the other hand, those whose per-
sonalities are capable of an integrative response to a moti-
vational contradiction may be mobilized to act at the peak
of their creative capacities by the urgency of the pressure
of such contradictions in their environment and probably
in their own personalities as well.[7] If so, *the qualitatively
successful forms of art can be regarded as the shapes of*

reconciliations of strong but contradictory motivations.
When such motivations coexist, artistic quality is more
needed; and artistic expression is more likely to be of high
quality when it does effectively reconcile.

While the action cycles depend to a great extent on the
decisions of the economic, political, or ideological elites
and counterelites of a society, motivational cycles consti-
tute largely "subterranean" popular processes which the
various elites merely articulate and, by articulating, chan-
nelize into more clearly defined "ideological" programs.
Thus, while the action cycles bring into play more directly
the influence of the various elites on artistic creativity, the
motivational cycles represent the influence that the "large
masses" of art consumers and the even larger "masses"
who come into contact with art consumers have on
artistic creation. The motivational cycles represent the
more "democratic," the action cycles the more "elitist" of
the sociological determinants of artistic creativity (in so-
cieties in which distinguishable elites can be identified).
The two types of influence are not, however, mutually ex-
clusive—just as the action cycles are not operated by the
elites alone and as motivational cycles do not necessarily
affect all the masses of art consumers. Furthermore, while
the elites cannot control motivation, they or the counter-
elites which challenge them can sometimes critically in-
fluence it. Only insofar as the various types of cycles affect
the leading elites as well as the "masses" *of art consumers*
are these cycles likely to influence artistic creativity. What
happens in the rest of the society affects art only to the
extent to which it affects the producers and consumers of
art.

THE INTERACTION OF CYCLES

An action cycle can, in principle, *always* be started anew or terminated by the beginning of a new action cycle or the unexpected intrusion of a different type of action cycle. While these processes may throw their shadow in advance of their occurrence, shadow-reading is an exceedingly uncertain enterprise.

In contrast, motivational cycles consist of long-term fluctuations during which movement tends to build up in one direction for great stretches of time, until accumulating signs begin to indicate an imminent reversal of direction. The exact point of reversal depends on a unique constellation of factors, including particular charismatic leaders and historical accidents, and is therefore in principle unpredictable. After the reversal, there typically follows another long stretch of basically consistent movement in a generally predictable direction. To be sure, fluctuations around the trend line do occur; motivational trends are not necessarily directly translated into comparable behavioral changes. But the degree to which change is self-determining and its fundamental pattern therefore predictable on the basis of knowledge of its previous direction would seem to be much higher in the case of psychohistorical than of social-action cycles.

The relationship between social-action and psychohistorical cycles is, however, reciprocal. On the one hand, action cycles may initiate, focalize, or inhibit motivational changes. A culture-mentality cycle may start with a specific, unpredictable social movement. The achievement-motivation cycle is affected by the degree of attainment of eco-

nomic or military success through social action. Both
satisfying success and permanent failure tend to reduce
achievement motivation. Demands for sexual control are
intensified in periods when states are being consolidated
and nations formed, and relaxed in periods of demobiliza-
tion of energies after the attainment of a major political
goal.[8] Emotionality may be heightened by disturbances of
social latency.[9] In all types of action cycles, a general re-
duction in the readiness to commit existing motivation to
problem-solving action appears to occur in the tension-
reduction phase. These are, obviously, descriptive state-
ments of probabilities, not of necessary prerequisites.

On the other hand, motivational cycles predispose the
population in which they occur toward particular kinds of
action and reduce the likelihood of other types of activity.
The predisposition constitutes one of the factors influenc-
ing the time of occurrence of action cycles and their in-
tensity, speed, extensiveness, and direction. Thus an eco-
nomic-action cycle is likely to begin when achievement
motivation is high, and to terminate when it has been
greatly reduced. A reformation is likely to start when
religious interest is either dramatically increasing or de-
clining—that is, in the disturbance-of-latency phase of a
psychoideological cycle. Reformations as powerful social
movements probably have to end when religious interest
has become either all-powerful or quiescent, in the latency
phase of a culture-mentality cycle. The latency phase of
psychohistorical cycles may reduce the readiness to initi-
ate wars. However, societies in this stage become tempting
objects of attack, so participation in war is not necessarily
avoided.

The action cycles also seem to show describable relationships among themselves. One of these relationships appears to be of a negative nature: The goal-attainment phases of several types of action cycles tend to occur at *different* times—for the pragmatic reason that if social resources are committed to intensive goal-seeking in one type of action cycle, there may not be enough of them left for intensive action in other cycles (except possibly in the advanced industrial societies, with their tremendous supply of resources).

The two goal-attainment phases most likely to occur at approximately the same time are the ideological and the communal. One reason for this correlation is the necessary element of community-building in any process of collective ideological conversion. Economic-goal attainment, on the other hand, frequently follows the goal-attainment phase of an ideological-action cycle (that is, economic transformations may be preceded by ideological movements, in the manner suggested by Max Weber).[10]

Another relationship among action cycles seems to be of a positive nature: The latency phases of several different action cycles not only can coincide theoretically, but also, in historical fact, occurred together in eighteenth-century Italy and Spain, periods of *generalized* latency.

The relationships among the other phases—disturbance of latency and integration—of the several types of action cycles seem to be historically more variable. Different types of phase conjunctions are possible. Thus, the artistic peak of Greece appears to have occurred in a period of economic integration and communal-goal attainment (as measured by internal-war data); the English peak, in a

period of incipient economic disturbance combined with communal integration; the Spanish peak, in a period of economic integration and an early phase of communal latency.[11] No particular *combination* of phases seems to characterize the artistic efflorescences. Thus, while several favorable phases may be needed for a creative period, *all* the social processes do not need to be in a favorable phase.

In contrast to the action cycles, there seems to be nothing to prevent any of the possible combinations of the phases of the psychohistorical cycles from occurring together. Middle-class England during the second quarter of the eighteenth century seems to provide an empirical approximation to a coincidence of the goal-attainment phases of the achievement-motivation, culture-mentality, and sexual-control cycles. The intense tensions of this period forged the socioeconomic dynamism that initiated the Industrial Revolution.

Urban Italy during the fifteenth century represents an empirical approximation to the coincidence of the integrative phases of the three psychohistorical cycles. This combination may be particularly favorable to artistic creativity.

Middle-class American society in the 1950's combined integrative phases of the achievement-motivation and the sexual-control cycles with Sensate latency. This combination may have helped to determine the "moderate," unexciting intellectual atmosphere of the period—"the end' of ideology" and so on. An increase in artistic creativity nevertheless occurred in it.

Current tendencies, in the "underground culture" of the fashionable avant-garde, to combine achievement-moti-

vation and sexual-control latencies with a disturbance of the Sensate equilibrium are reminiscent of literary Europe in the 1890's and of cultivated Greece after the third century B.C. Such periods seem to be characterized by a kind of emotionally turbulent waiting or frenetic stagnation.[12]

A combination of achievement-motivation and Sensate latencies with an integrative phase of the sexual-control cycle, as perhaps in eighteenth-century Spain, may tend to produce cultural stagnation of a more quiescent kind.

These illustrations can only be suggestive of the numerous possible linkages between the phases of the psychohistorical cycles and of the differential impacts of these combinations on the "sensibility" as well as creativity of a period. The approach suggested could make it possible eventually to devise a series of categories in terms of which the motivational "formula" of each major historical period would become identifiable. Style characteristics—and even the content of art—should be affected by the particular combination of the phases of the various psychohistorical as well as social-action cycles occurring in a period; and some "recurrences" of styles may be explicable in these terms. The advantages, in permitting a *differentiated* analysis of processes and states of civilizations, of this type of cyclical theory over those represented by Spengler, Toynbee, or Sorokin should be obvious. The immediate interest here, however, is merely to demonstrate that, while the various types of cycles interact, they must be regarded as processes that are to some, perhaps variable, degree independent of each other, and that therefore, if artistic creativity is to be explained, they must *all* be studied.

It seems reasonable to expect that since the psychohis-

torical cycles have their anchorage in the motivational system of the personality (which is likely to be far more integrated within itself than the different types of social processes are with each other), the psychohistorical cycles will tend to occur in closer conjunction with each other, and the social-action cycles to be more independent of each other. Nevertheless, the motivational cycles are not to be regarded as isomorphic or as restatements of exactly the same empirical process under different intellectual categories.

In Greece and Spain, achievement motivation and Ideational orientation apparently kept declining through the periods analyzed by McClelland and Sorokin, more or less in unison.[13] In England, however, the eighteenth-century increase in achievement motivation (indicated in literature) was not associated with any noticeable increase in Ideational orientation (registered in visual art). The Ideational hypothesis could also hardly account for the high achievement motivation of the elites in the twentieth-century Communist societies; [14] achievement is linked with a Sensate mentality—although one with a hidden "mythical" component—in this case. What happened in both eighteenth-century England and twentieth-century Russia could be explained in part by the hypothesis that increases in achievement motivation are brought about by revitalization movements, whether religious or secular ideological.[15]

Sexual restrictiveness may be more closely associated with achievement motivation than either Ideational or Sensate mentality is, since the first correlation apparently obtains in both eighteenth-century precapitalist (middle-

class) England and twentieth-century Communist Russia,[16]
and declines in achievement motivation tend to be asso-
ciated with increasing sexual permissiveness. In both En-
gland and Russia, sexual restrictiveness was or became
an element of the program of the revitalization movements,
and it might be contended that sexual inhibition without
a revitalization movement, or vice versa, would not have
the same enhancing effect on achievement motivation that
both in conjunction have. This is an interesting possibility,
since the "postmodern" revitalization movements (that is,
those occurring in advanced industrial societies) have
tended to reject restrictive norms of any kind.

They are also likely to subordinate economic achieve-
ment either to cultural creativity or the maintenance of
humane values. Such movements may stimulate artistic
interests in the short run. Will they, however, initiate the
long-range psychological dynamics affecting artistic *creativ-
ity* that the "early modern" (achievement-oriented, sexually
restrictive) type of revitalization movement generated?
Societies at different stages of the Industrial Revolution
may require and benefit from revitalization movements
with specifiable differences in their ideological and moti-
vational content. Yet it does not follow that the outcome
of various postmodern types of revitalization movements
will necessarily be a long-range enhancement of the cre-
ative capacity—particularly if such movements continue to
be oriented to the consumption rather than the produc-
tion of whatever they are concerned with.

So far as artistic creativity is concerned, the effects of
psychohistorical cycles cannot easily be disentangled, ex-
cept possibly through a series of intensive case studies, from

the effects of the social-action cycles with which the former are interrelated. It is the creative *capacity* which seems, to a significant extent, to be built up and dissolved in the course of the psychohistorical cycles. It is the *social demand* and support for art that seem, to a significant extent, to be determined by the social-action cycles. Both types of processes influence artistic creativity. But the effects of social-action cycles seem to be more immediate than those of the psychohistorical cycles.

A combination of artistically favorable phases of several action cycles might conceivably produce a minor artistic peak, even in the absence of the three types of favorable motivation—tensions between drives toward achievement and toward expression, between Sensate and Ideational mentalities, and between asceticism and eroticism—that have been identified here. Conversely, the conjunction of artistically unfavorable phases of several action cycles could preclude the development of an artistic efflorescence even if the favorable types of motivation were present. In this case, one would expect a good deal of creativity in types of art, such as oral literature or culturally standardized visions, that require few social resources other than interest.

However, while the goal-attainment phase of an *action* cycle may prevent the self-actualization of motivation tending toward creativity, it seems hardly possible to conceive that powerful motivation favorable to creativity in the personality systems of any large number of individuals can coexist with the latency phase in the social system—unless the creative or potentially creative people are so

completely alienated from the society that the society is either unaware of their existence or accepts their passion for its entertainment value. Rather, motivation toward creativity in the personality system seems apt to disturb the relative equilibrium of the social system—and may in this manner raise the latter's level of aggressiveness.[17] This may be one explanation of the finding, in a factor analysis of forty contemporary nations, that "creative" variables, such as "high creativity in science and philosophy," "high musical creativity," and "many Nobel Prizes in Science, Literature and Peace," tended to cluster together with the "aggressive" variables, such as a "large number of riots" and "frequent involvement in war." [18] This clustering appears to provide additional support for the earlier contention that periods of sociological latency might prove to be both less creative and less aggressive than those of disturbed equilibria.

Given the accumulated artistic traditions and skills, artistic creativity will receive the greatest sociological stimulation when the favorable phases of the various social-action and psychohistorical cycles are closest to convergence. Complete convergence, however, is neither necessary for an artistic efflorescence nor expectable in historical reality. Indeed, a conjunction of too many creativity-provoking phases might produce a situation of such explosiveness that even a tremendously successful civilization, perhaps like that of classical Greece, could not be sustained for very long. Artistic efflorescences could perhaps be supported effectively by several *different* combinations of the favorable factors that have been identified.

CONCLUSION

Most works of art produced in even the highly creative periods do not constitute great artistic values. Conversely, some works produced in historical periods that were not highly creative have enduring merit. But works of art seem less likely to attain qualitative excellence if the society in which they are produced does not infuse artists with the energy to do their creative best by presenting them with problems of socioemotional integration that art is uniquely qualified to solve.

Artistic creativity is a mechanism for the transmutation of social and motivational (but not, so far as our evidence goes, psychiatric) disturbances into cultural products; [19] the ability to create art is derived, in significant measure, from such disturbances.

But if creativity is the normal consequence of disturbance, stagnation is the normal consequence of achievement. Perhaps it is the failure of a social process to reach its normal termination that needs to be explained.

10. Some Social Functions of Artistic Values

The theoretical structure of this study, as originally en-visioned, is now complete. A few ideas that have developed from the inquiries conducted but that remain beyond their scope will be adduced, even more tentatively than the ana-lytical generalizations proposed earlier, in the two final chapters.

IMPLICATIONS OF THE PHASE-CYCLE THEORY

The relationships between artistic creativity and the processes of social action treated in Chapters 2 through 5 suggest the hypothesis that *artistic values function as man-made devices for attaching private emotions to the patterns of organization and the cultural symbols of a society,*[1] *when emotion has become detached from society and culture.* The relationships between artistic creativity and historical changes in motivation analyzed in Chapters 6 through 8 suggest that *artistic values arise from the need to reconcile contradictory motivations when one is not sufficiently strong to dominate or suppress the other in the personality system.*[2]

Artistic values appear to be responses to the felt need for relating men's emotions to their sociocultural environment and for coordinating different types of motivations in a nonrepressive, nonhierarchic, "egalitarian" manner with each other. The creation and perhaps even the experience of high-quality art would seem to be possible to the extent that men or women neither subjugate their emotions to the "objective" structure of the existing society and its established cultural abstractions nor exalt their emotions far above objective reality, and to the extent that they do not subordinate one set of their own motivations to another. Great art, by projecting a sense of interrelation and coordination without denying the authenticity and independence of the contradictory elements entering into it, suggests a "liberating" and "humanizing" attitude. Art (of all "cultural logics," perhaps art alone) imposes the kind of structure on experience that permits the nonrepressive coexistence of contradictory qualities. Destroying this structure—the coherence of art—would result not in freedom, but in some kind of repressiveness. There is no assumption here that great art "humanizes" by inculcating moral sensibilities or humane attitudes. It may do so, but not because it is great art. The need which artistic values are assumed to meet is the need for a socioemotional, not an ethical, pattern.

When art is qualitatively successful, not merely an attempt at artistic statement but a historically recognized aesthetic attainment, it probably constitutes more than an expression of a *need* for integration. It may be the means or the record of the process of meeting this need. If so, what the relative consensus of art historians has established

as the higher attainments of art history could be regarded as the repository (and the story of the evolution) of the effective devices that men have invented for integrating their contradictory emotions and coordinating them with their social institutions and with the organization of beliefs and values of their culture. At least, this point of view underlines the general social significance of great art, and it may provide a sociological clue to the understanding of what constitutes artistic value. Perhaps artistic value could be conceived of as *a form that has the capacity to suggest a possible integration of a historically specific set of social conditions with a historically specific set of human emotions that continues to be recognizable, across history and transculturally, for the psychological effectiveness it may have once possessed.*

I am assuming that it is the "mysterious," "charismatic" *power of integration* of socioemotional tensions that is recognized as the ground of artistic values. There is a sense of elements that must have clashed, thus providing the "energy" of the work of art, and of a solution that incorporated the clashing elements into a larger pattern, the "significant form" of the work of art. The particular socioemotional tensions at the basis of a work of art need not be recognized cross-culturally and transhistorically, but rather the power of bringing together *whatever* may have been disparate must be sensed in a work of art judged to be of high aesthetic quality beyond the sociohistorical system in which it was produced. To understand a work of art, it may be necessary to know the historical particularities; to appreciate its artistic value, it seems sufficient to have a sense of the integrative potency inherent in it. A

work of art with a highly generalized integrative potency should lend itself to resolving contradictions quite different from those it originally expressed. It permits different kinds of "reading." (For a hypothetical identification of some of the sociocultural elements that should nourish this highly generalized integrative potency in a work of art, see Chapter 11.)

If this is a valid interpretation, it follows that high-quality art reveals the sociopsychological facts of the period in which it was created more faithfully than does low-quality art. Three essential qualifications are, however, in order: First, high-quality art presumably brings out those social factors that come into a state of tension with emotion, and those motivations which are challenged by their opposites of a similar intensity; such art will not necessarily reflect those "stable points of reference" that remain unthreatened. Second, high-quality art presumably reflects the tensions and contradictions which (if only in the work of art itself) reach a resolution. Such art may not reflect the tensions and contradictions that remain unresolved *both* in the society in which it is being produced and in its art style. An art work that reflects *socially* unresolved contradictions and does not resolve them in its own *artistic* structure, seems less likely to attain an "aesthetic toughness" that endures in history. Third, where the art-using community does not coincide with the whole society, it cannot be presumed that the contradictions great art registers are prevalent in the whole society and that the social functions such art performs are sensed throughout the society. It can only be assumed that art reflects what is happening among its producers and consumers as well as, in modern times, among those—dealers, critics, party hacks—who me-

diate between artists and their publics. And art can directly affect only those groups.

STYLE AND THE ESTABLISHMENT OF CONNECTIONS

The assumption that artistic value *entails* contradiction is supported by indications that what are judged as the highest attainments in the history of art have been created in times in which a lack of integration between social structure and emotion and contradictions between different types of motivation were both widely experienced and socially salient (in the sense that resources of the society could be, and were, devoted to solving these problems).

If art is to have the function of intensifying the awareness of disjunctions, it should be most needed when little such awareness exists (i.e., in periods of social and cultural latency). The fact that art appears to be more needed and more creatively practiced by artists in periods in which social disturbances and cultural tensions already exist, as a result of historical events rather than anything that the artists themselves may have done, suggests that the creative moments of art come from efforts to put what is disjointed in order.

The assumption that artistic value is not a passive reflection of social and cultural disjunctions, but rather that it represents, in its own formal structure, a *resolution* of contradictions is based on the theoretical tradition which assumes that style consists in the establishment of coherence among the elements of perception embodied in a work of art and that style, conceived in this manner, is a necessary condition of art's existence.[3] Such an assumption is now widely questioned by some aestheticians and a good many fashionable avant-garde artists. But it would pre-

sumably be supported by most psychologists, who point to a tendency to seek consistency (though not necessarily absolute consistency) and patterning in perception as a generic human characteristic.[4]

The human mind is attracted by inconsistency and formlessness—the "rage for chaos"—when it judges a situation to be characterized by excessive consistency and patterning and therefore experiences it as boring or oppressive. The dynamic which encompasses both "the trend toward consistency" and its opposite seems to be directed toward the attainment of temporarily gratifying balances between structure and spontaneity. An evolving style appears to be capable of attaining this temporary and open-ended coherence. Style may be conceived of as a congenial *mode of establishing connections,* whether harmonious or conflicting, among the elements of experience. (Establishing a connection between contradictory elements is not identical to denying or even "overcoming" the contradiction.) While the destruction of a mode of establishing connections is at certain times socioculturally and psychologically necessary, the means of destruction are not likely to arrange themselves into an artistically successful style. The "aesthetics of destruction" indeed tends consciously to reject "art."

It is possible to conceive of style in some other way and even to question its necessity in art, substituting complete randomness—or a conscious production of chaos—for style.[5] But if it is assumed that the need for integrating social reality and personal emotions (including the emotions that accompany a rejection of social reality) is an intrinsic human need and the "task of art" is to meet it, the type of art which merely reflects or intensifies disconnection should fail as art and eventually be recognized by

artists and art historians as having failed. If this should happen, the failure will have to be judged as due at least in part to a faulty conception of the sociocultural functions of art.

The faulty conception seems to arise from the implicit assumption that art is a means of responding to boredom or meaninglessness. But most of the accumulated historical evidence suggests that great art is far more likely to spring from various states of tension—which are by definition highly "interesting" and "meaningful," even if also extremely uncomfortable—rather than from boredom. If boredom generated art, the American Indians on their reservations should have become highly creative, but their creativity more often than not declined after they were forced into the reservations. Roman history suggests another type of causal sequence: boredom in the second century A.D., new spiritual strivings in the third, a revitalization movement in the fourth, a revival of artistic creativity in the fifth. The response to boredom can be social action or motivational changes, and only from such action or changes do great periods of artistic creativity emerge.

To counter boredom and introduce an element of chaos into the social order may be a function of experimentation as an activity rather than of artistic values as products. Poggioli speaks of "an impossible synthesis" between "creation *and* experimentation. . . . In reality, experiment precedes creation." [6]

A "POSTMODERN" PROBLEM

A peculiar problem, however, arises for art in a contemporary, highly bureaucratized society. In this type of society, social order may be felt to be so emotionally

stifling that a kind of art that infuses a vivid sense of chaos or randomness into the social order becomes psychologically attractive, even when it does not perform what has been conceived of here as the social function of artistic values— a reconnection of emotions with social conditions and a coordination of contradictory motivations. Art theories that celebrate "the rage for chaos" become popular.[7]

Such theories are symptomatic of a state of perceptual disorientation, in which people no longer have a way of seeing that they can sense as their own.[8] They therefore have no possibility of judging how well this (or any other) way of seeing is revealed in objectified works of art. They will resist evaluative criticism of their works. But they may also have an impaired capacity to create values.[9]

Celebrations of the sacred disorder of one's soul are artistically fruitful when there is too much traditional order in the world outside. When the world becomes perceptually disoriented, the task of the artist might be construed as the search for convincing limits to amorphousness, for structure beyond liberation, for a sense of the "permanently treasurable," to be gained from committed craftsmanship.

The decline of the avant-garde since the 1930's—or, in America, since the 1950's [10]—seems to me due to a failure to understand that its historical role to press against confining structures has lost most of its point—not everywhere, but precisely where the avant-garde culture is created and appreciated. The avant-garde can probably regain its vitality only by reversing its own tradition: by pressing now against its own anomie and its ritualism of innovation.

11. Speculations on the Excellence of Forms

Is it possible, on sociological grounds, to specify any of the characteristics of artistic forms that tend to make the psychological effectiveness they once possessed universally recognizable?

THE ESSENTIALITY OF FORMS

The analysis of the social-action cycles in relation to artistic creativity suggests the following answer. If artistic creativity increases when art is needed in a society as a means of achieving socioemotional integration, the increase may be due to the artists' greater ability, in such periods, to impart to their works some quality suggesting that they have an "essential" reason, a kind of existential necessity for being what they are. I would judge styles as diverse as the Gothic, the Renaissance, and the baroque, and as Mondrian's and Pollock's, to be essential in this sense.

When art is not in fact needed by the society of the artist, it may be difficult for artists to give it forms that suggest any sort of existential necessity for their being. When art is not needed by those for whom it is being

produced (the actual or potential public for art in the society of the artist), artistic works are apt to convey a sense of superfluousness or irrelevance or arbitrariness, even when the artists are ambitious to make significant statements. Such ambitions tend in these periods to remain buried in the content instead of being translated into the forms of works of art, or they may inhere in the programmatic statements of the artists or in the way they enact their social roles instead of in their works.

The artist, however, is a part of his own public. If he has an intense sense of need for his own art, this sense may partially offset the indifference of the society to art and render him capable of creating "essential" art. When an artist senses that his society does not need art, in order to create essential works of art he must have a *particularly* intense personal need for art, an obsession that enables him to remain relatively unaffected, in his capacity to create, by the indifference of the society toward the objects of his creation. The great artists of the classical age of modernity, from Van Gogh and Cézanne to Jackson Pollock, have typically possessed this internal compulsion.

On the other hand, one reason for a society's "not needing" art is that the forms of the art being created express their own superfluousness—perhaps because leading artists have ceased to have any specific personal need for the art they are producing. This may be one of the unintended consequences of greatly increased profitability in the art market in conjunction with a celebrity cult in the arts. These two factors tend to transform artists into makers of commodities or entertainments that are wholly sufficient as commodities or entertainments—and that one does not

have any particular psychological need to make or to perceive. A situation arises in which, even though art is needed in a society to perform functions that only art can perform, the need cannot be sensed—even by a great many of the artists themselves—and, consequently, art cannot be created in a form that meets the need. Such a situation, however, seems to be capable of becoming established only in capitalist societies in an advanced industrial stage of development. But then it provides the basis for the "crisis of creativity" in these societies—and for a consistently negative qualification of the predictions of efflorescences that would be made on the basis of the phase-cycle theory of artistic creativity alone.

"Superfluous" art may be described as art that just *is,* but that—especially from the perspective of an unindoctrinated outsider—carries little conviction of the necessity for its being as it is. Dadaism and much of the pop, electronic, "inflatable," and "conceptual" art of the recent decades seem to me to be *artistically* superfluous, as the term has been defined here. While artistically superfluous, these styles may yet be highly significant as cultural-psychological documentation of a period or of the perceptions of particular groups within a population.

Until recently, superfluousness appears to have been relative. Styles described as "precious" or even "pretentious" and "artificial" have not been wholly without artistic merit. The artistic value of styles deficient in essentiality presumably derives from the presence, to a greater or lesser extent, of characteristics discussed in the following section. These characteristics may indeed be more important than essentiality in determining artistic value. If this

is so, an essential style that is not very high on the scale of artistic values is conceivable (constructivism in painting is perhaps an example).

The conception of essentiality leads to highly subjective judgments, which only the emerging consensus of artists and art historians may be able to validate. I therefore suggest a second approach to the problem of the artistically valuable form, derived from the analysis of the motivational conditions of artistic creativity, the psychohistorical cycles.

THE GENERAL SUBSTANCE OF ARTISTIC VALUES

It seems probable that if artistic creativity is greatest in the periods when achievement motivation is balanced against the expressive interest, the forms of art created in such periods will *reflect* this motivational balance. That is, the forms of art created in such periods will—more frequently or effectively than in other periods—balance energy against expressiveness. Similarly, if artistic efflorescences occur when empiricist and mythical orientations are balanced against each other and a high degree of feeling is invested in social objects, the forms of art works created in such periods should reflect these motivations.

The hypothesis emerges that artistic values in the visual arts are most likely to be realized in forms which balance suggestions of energy against those of expressiveness, and reflections of a trust in the senses against intimations of a commitment to metaphors of something that transcends the experience of the senses, and which are permeated by feeling. Such forms, however, are likely to emerge spontaneously only in periods when a society or a particular

group within it provides the corresponding types of motivation for its artists to employ in their work. In other periods, artists may consciously choose to open themselves up to these kinds of motivations, as embodied in the experience, thought, and art of the past or of contemporary societies other than their own. But they can only immerse themselves in these materials and wait for their own spontaneous responses. If art forms are to be authentic expressions of the men and women who make them, the forms cannot be *willed* into existence.

If each pair of balanced tensions—there may be others, still to be empirically identified [1]—is separately associated with the great periods of artistic creativity, can it be argued that each carries an essential component of artistic value (or an essential component of one type of artistic value)? And can it be argued, furthermore, that a greater or more universal artistic value will emerge when all three types of tension are present in the historical environment and reflected in the works of art arising therein? Can, therefore, the ultimate substance of the visual arts, that which has to be added to technical, learnable skills, be conceptualized as a synthesis of energy and self-expression, sense perceptions and faith (not necessarily a supernaturalistic religion), and concentrated feeling—expressive energy felt in a sensuous metaphor?

This, in any case, is my *general* (though very probably incomplete) formula for artistic values, derived from a study, not of specific works of art, but of the motivational characteristics of the periods of greatest artistic creativity. I suppose that the general formula could be applied to Renaissance as well as Aztec, Chinese as well as Indian,

Paleolithic as well as African art. In the absence of any of the elements of the formula, an art work seems likely to be perceived, in some significant respect, as "unbalanced," limited, one-sided, even when it is "essential." However, the general characteristics of artistic values have to be embodied in a *specific* style, and presumably this style must be congruent with the fantasy dispositions characteristic of the particular society in which it is employed.

THE SOCIOCULTURAL ADEQUACY OF STYLE

Fantasy dispositions may be defined as characteristic—but not necessarily permanent—tendencies that develop in the personality structures of individuals located in a particular sociocultural environment to perceive the intrinsic qualities of objects, real or imagined, in a particular way. For a style to be an expression of the society in which it was created, it must express the fantasy dispositions or tendencies of perception prevalent in that specific society, or at least among its art-using members. Idiosyncratic elements in fantasy disposition must be presupposed, but they will not be considered here.

I would hypothesize that the ability of a society to attain an artistic efflorescence is contingent on its acquisition of a formal vocabulary that is "psychologically congruent"— that corresponds, in the emotional states suggested by its structure—with the fantasy dispositions shaped *both* by the social conditions and, especially, the dominant value orientations of the society or of its art-using groups. Fantasy dispositions, however, appear to develop as *either* direct *or* inverse reflections of social conditions—as either their objective representations or as imaginations of the

precise opposite of "social reality." [2] This may also be true of the relationship, at any given time, between fantasy dispositions and established cultural traditions.

Any society, moreover, has numerous structural characteristics and cultural orientations that might be expressed in its art style and render it an authentic product of its sociocultural environment. Artists are engaged in *selecting* which characteristics of the structure and cultural orientations of their society or of some group therein to reflect—directly or inversely—and how to *combine* these reflected elements into a single, internally consistent style. A great many styles may be authentic expressions of a complex sociocultural environment, but each authentic style must consist of a selection of socially provided elements, and these elements must be combined in such a manner that they coalesce into an organic whole or enter into a dialectic of opposites contained within a dynamic whole.

Thus abstract expressionism combines the formal characteristics suggestive of social mobility (informality and dynamism) with those indicative of an orientation toward the future (the abandonment of clearly defined space, formal roughness). Its forms are, furthermore, expressive of individualistic values (subjectivity, complexity, painterliness), of a romanticized version of puritanism (a refusal to worship the things of the flesh, "doing," universalism), and of "the increasing disjunction of culture from social structure" (abstraction, randomness).[3] These characteristics, each reflecting a single element of social organization or cultural tradition, have been fused into an organic whole, a formal synthesis of a diversity of real characteristics of the society in which it originated. The style, fur-

thermore, contains the elements of the general substance of artistic values, as previously identified, and carries a convincing sense of its own essentiality. Therefore, abstract expressionism could be both aesthetically successful and socially popular in America.

In contrast, op, pop, electronic, and inflatable works of art seem to me to have only sociocultural adequacy going for them—which makes them documents of cultural psychology rather than examples of artistically valid styles. Artistic values must be more than authentic exemplifications of the modes of perception of a particular period; otherwise their appeal could not transcend that period. Furthermore, each of these styles seems to express relatively few sociocultural characteristics of its environment. And perhaps the more characteristics of the social structure and of the cultural orientations of a society an art style succeeds in reflecting and synthesizing in its designs— the richer the content of its style—the more capable it will be of supporting high creative attainments.

The selection among prevalent sociocultural characteristics is the task of the individual imagination of the artist, a specialist in perception and in the integration of social conditions with personal emotions. Since he does not have to "reflect" all the characteristics of his sociocultural environment in any given artistic statement, and since his "reflection" can be either direct or inverse, he can both truthfully reveal what others also sense and express his own individuality in his choice of the elements to reflect, the ways to reflect them, and the total constellation he makes of these elements and ways. Thus, it is possible for an artist who is alienated from numerous aspects of his society

and culture to create styles that will be widely popular among less alienated art-consumers—presumably, partly on the strength of the authentic reflection in his style of the characteristics of his sociocultural environment from which he has not been alienated and about which others feel as he does. When they discover socioculturally adequate and yet personally expressive form constellations, individual artists become important in influencing the level of creative attainments in their societies.

Since social structures, cultural orientations, and art styles change at different rates of speed under the influence of different factors, a congruence of style with the sociocultural universe cannot be taken for granted, especially in the modern or modernizing societies. Perhaps, particularly in periods of rapid social change, the artistic idiom that expresses the *spontaneously emergent* value orientations is even more favorable to the attainment of excellence than styles that are psychologically congruent with only the established orientations.[4] If this is the case, one social function of style would be to help clarify to the conscious mind the subliminally emerging value orientations of a society or, especially in the modern period, of an international civilization. If this is indeed a function of art and if art's level of excellence depends on how well it performs its functions, one would expect the artistic centers of the modern period to develop at the growing edges of modernity, in cities embodying "the look, tempo, the texture of the historical moment."[5] The movement of the center of artistic creativity, after World War II, from Paris to New York might be thus explained in part.

If, however, the obligation to express what is consciously

defined as the direction of the future is rigidly imposed on art, creativity seems likely to suffer. Political dogmas, such as Soviet Communism, as well as aesthetic doctrines, such as avant-gardism for its own sake ("in many cases . . . more interested in motion than in creation, gestures than acts") [6] may have this effect. Indeed, a strong orientation toward the future in a society, even without specific reference to art, may not provide the most favorable atmosphere for artistic creativity.[7] On the other hand, the imposition of rigid reactionary programs on art and the society as a whole, as Ming China demonstrated, affects artistic creativity in a similarly negative manner. Art, especially in the long run, seems to benefit from a mellowness of artistic programs.[8]

A SUMMING UP

The evidence reviewed suggests that art of high quality is most likely to emerge where and when the skills of craftsmen are conjoined with specific sociocultural adequacy, general artistic substance, and historic essentiality.[9] When practicing artists and art scholars judge artistic merit, they are not explicitly looking for the presence or absence of these sociologically conceived variables. But what they esteem in the long run is a perfection beyond craftsmanship which can most probably be achieved when social conditions exist for art to be historically essential, artistically substantial, and socioculturally adequate.

NOTES AND INDEX

Notes

1. On Studying Artistic Creativity

1. "I have followed the books, and their consensus is fairly close" (A. L. Kroeber, *Configurations of Culture Growth* [Berkeley: University of California Press, 1944], p. 23). To be sure, Kroeber found textbooks and encyclopedias to be the most convenient sources, the first "on account of their timidity about departing from the accepted norm," and the second because of their "freedom from argument or novel opinion." Whatever consensus art historians achieve is probably exaggerated in encyclopedias and textbooks but can hardly be merely the result of conformism by the compilers of the latter.

2. C. S. Ford, E. Terry Prothro, and Irvin L. Child, "Some Transcultural Comparisons of Esthetic Judgment," *Journal of Social Psychology,* 68 (Feb., 1966), 19–26; I. L. Child and Leon Siroto, "BaKwele and American Esthetic Evaluations Compared," *Ethnology,* 4 (1965), 349–360; Sumiko Iwao and Irvin L. Child, "Comparison of Esthetic Judgments by American Experts and by Japanese Potters," *Journal of Social Psychology,* 68 (1966), 27–33.

3. Jakob Rosenberg, *On Quality in Art: Criteria of Excellence, Past and Present* (Princeton, N.J.: Princeton University Press, 1967), finds that the criteria for the judgment of artistic

quality have remained fairly stable over several centuries in the West, in spite of variations in styles.

4. The more parochial judgments of nonartists may provide a partial explanation of the extreme fluctuations in the market value of a great many Western works of art. See Gerald Reitlinger, *The Economics of Taste: The Rise and Fall of the Picture Market, 1760–1960* (New York: Holt, Rinehart, & Winston, 1961).

5. Arnold Hauser, *The Philosophy of Art History* (Cleveland: World, 1963), p. 8.

6. Kroeber's *Configurations of Culture Growth* constitutes the most systematic statement of his theory of creativity. In addition, see his *Style and Civilization* (Ithaca, N.Y.: Cornell University Press, 1957), and for critical analyses of Kroeber's ideas, Pitirim A. Sorokin, *Social Philosophies of an Age of Crisis* (Boston: Beacon Press, 1951), pp. 159–175, 260–266, and Thomas Munro, *Evolution in the Arts and Other Theories of Culture History* (Cleveland: Cleveland Museum of Art, 1963), pp. 515–520.

7. André Leroi-Gourhan, *Treasures of Prehistoric Art* (New York: Abrams, 1967), p. 216.

8. Pitirim A. Sorokin, *Social and Cultural Dynamics*, I (New York: American Book Company, 1937).

9. See Chapter 7. Sorokin does not think that the second alternative is as stimulating to the arts as the first.

10. Pitirim A. Sorokin, *Society, Culture, and Personality: Their Structure and Dynamics* (New York: Harper, 1947), pp. 540–545.

11. *Ibid.*, p. 544. See also his *Man and Society in Calamity: The Effects of War, Revolution, Famine, Pestilence upon Human Mind, Behavior, Social Organization and Cultural Life* (New York: Dutton, 1942).

12. Sorokin, *Man and Society in Calamity*, pp. 258–259.

13. Charles Edward Gray, "A Measurement of Creativity in Western Civilization," *American Anthropologist,* 68 (1966), 1384–1417. His terminology ("degenerate modernism" for artistic developments since 1935) and assigning of styles to periods also seem somewhat arbitrary. John P. Sedgwick, *Rhythms of Western Art* (Metuchen, N.J.: Scarecrow Press, 1972), develops a similar approach, but was published too late to be considered in this book.

14. Ronald Jay Silvers, "Alienation and Creativity," paper presented to the Sociology of Knowledge section, Sixth World Congress of Sociology, 1966.

15. Alvin W. Wolfe, "Social Structural Bases of Art," *Current Anthropology,* 10 (Feb., 1969), 3–29.

16. Exceptions are Don Martindale, *Social Life and Cultural Change* (Princeton, N.J.: Van Nostrand, 1962); Lewis S. Feuer, *The Scientific Intellectual: The Psychological and Sociological Origins of Modern Science* (New York: Basic Books, 1963); and Joseph Ben-David, *The Scientist's Role in Society: A Comparative Study* (Englewood Cliffs, N.J.: Prentice-Hall, 1971). The "extraordinary increase in the study of creativity" in psychological literature in recent years has not manifested itself in sociology (J. W. Getzels and M. Csikszentmihalyi, "On the Roles, Values, and Performance of Future Artists: A Conceptual and Empirical Exploration," *Sociological Quarterly,* 9 [Autumn, 1968], 516).

17. Talcott Parsons and Robert F. Bales, "The Dimensions of Action Space," in Talcott Parsons, Robert F. Bales, and Edward A. Shils, *Working Papers in the Theory of Action* (Glencoe, Ill.: Free Press, 1953), pp. 63–109; Talcott Parsons and Neil J. Smelser, *Economy and Society* (Glencoe, Ill.: Free Press, 1956), pp. 242–243.

18. Sorokin, *Social and Cultural Dynamics,* IV (1941), 441–554; Robert A. Nisbet, *Social Change and History: Aspects of*

the Western Theory of Development (New York: Oxford University Press, 1969).

19. Phase cycles are defined in terms of that component of the total population which has some independent capacity for action and which, therefore, by virtue of its actions or failure to act, has influenced the course of historical developments (including those of art history). In the course of social evolution, the percentage of the total population of a society who could be regarded as phase-cycle definers has presumably declined during the development from preliterate band societies to absolutist agricultural empires and increased between the time of the latter and the period of "populist" democracies; it may also increase, temporarily, during revolutionary periods.

20. C. E. Black, *The Dynamics of Modernization: A Study in Comparative History* (New York: Harper & Row, 1966), pp. 67–68.

21. W. W. Rostow, *The Stages of Economic Growth: A Non-Communist Manifesto* (Cambridge, Eng.: University Press, 1962), pp. 80–92; Daniel Bell, "The Year 2000—The Trajectory of an Idea," *Daedalus*, 96 (Summer, 1967), 639–651; Irving Howe, ed., *Literary Modernism* (Greenwich, Conn.: Fawcett, 1967), pp. 11–40; and my own "Post-modern Man: Psychocultural Responses to Social Trends," *Social Problems,* 17 (1970), 435–448.

22. Anthony F. C. Wallace, *Culture and Personality* (New York: Random House, 1961), pp. 143–156.

23. Quincy Wright, *A Study of War* (Chicago: University of Chicago Press, 1942), I, 118–119.

24. Marshall D. Sahlins and Elman R. Service, eds., *Evolution and Culture* (Ann Arbor: University of Michigan Press, 1960), chap. v; and Arnold J. Toynbee, *A Study of History,* IV (London: Oxford University Press, 1939), 245–584.

25. Sorokin, *Society, Culture, and Personality*, pp. 435–436; Seymour Martin Lipset and Reinhard Bendix, *Social Mobility in Industrial Society* (Berkeley: University of California Press, 1960), p. 74.

26. Suzanne Keller, *Beyond the Ruling Class: Strategic Elites in Modern Society* (New York: Random House, 1963), p. 247.

27. Sahlins and Service, *Evolution of Culture.*

28. "Because the phenomenon of expressive communication" is related "to the problem of order," the discharge of motivational energy "without reference to adaptive exigencies . . . is a process peculiarly bound up with integrative exigencies" (Talcott Parsons, Robert F. Bales, and Edward A. Shils, "Phase Movement in Relation to Motivation, Symbol Formation, and Role Structure," in Parsons *et al., Working Papers,* p. 190).

29. I have pursued these questions in "Social Evolution, the Organization of the Artistic Enterprise, and Creativity," *ARIS* (Art Research in Scandinavia), 1969, No. 2, pp. 1–8; and "The Possibilities of an American Artistic Efflorescence," *Journal of Aesthetic Education,* 4 (Oct., 1970), 21–36. On the complex interrelations between scientific and artistic creativity, see Cyril Stanley Smith, "Art, Technology, and Science: Notes on Their Historical Interaction," *Technology and Culture,* 11 (1970), 493–549.

2. *Economic-Action Cycles*

1. For a definition of artistic creativity, see Chapter 1.

2. Shepard B. Clough, *The Rise and Fall of Civilization: An Inquiry into the Relationship between Economic Development and Civilization* (New York: Columbia University Press, 1961), p. 261.

3. See Chapter 1.

4. About Athens, see Pitirim A. Sorokin, *Social and Cultural Dynamics, III* (New York: American Book Company, 1937), 231; about China, Peter C. Swann, *Chinese Painting* (New York: Universal Books, 1958), p. 33; about Egypt, A. L. Kroeber, *Configurations of Culture Growth* (Berkeley: University of California Press, 1944), p. 240; about Mesopotamia, *Encyclopedia of World Art,* hereafter cited as *EWA* (New York: McGraw-Hill, 1959–1967), I, 856; about Rome, France, and Germany, Pitirim A. Sorokin, *Society, Culture, and Personality: Their Structure and Dynamics* (New York: Harper, 1947), pp. 549–550; about the Romanesque age and Renaissance Italy, Arnold Hauser, *The Social History of Art* (New York: Vintage Books, 1957), I, 183, and II, 12–13. However, the "revivals of political strength and economic prosperity" under the Ming and Manchu dynasties in China resulted in no "important measure of cultural creativeness of patterns" (Kroeber, p. 671).

5. About the Hellenistic age, see Clough, p. 114; about the Italian Renaissance, Hauser, II, 29; about the fifteenth-century Low Countries, Kroeber, p. 363; about seventeenth-century Holland, George Edmundson, *History of Holland* (Cambridge, Eng.: University Press, 1922), pp. 120–121, 186, 298. The British efflorescence of the eighteenth century (when Dutch art was stagnant) was preceded by the ascendancy of London over Amsterdam as the center of "international financial business" (G. N. Clark, *The Seventeenth Century* [2d ed.; Oxford: Clarendon Press, 1957], p. 45).

6. W. Stephenson Smith, *The Art and Architecture of Ancient Egypt* (Baltimore: Penguin Books, 1958), p. 123; Jean Gimpel, *The Cathedral Builders* (New York: Grove Press, 1961), pp. 40, 176, 178; Richard Ettinghausen, *Arab Painting* (Lausanne: Skira, 1962), p. 183. The economic welfare of

Benin State, based in part on slave trade, declined in the seventeenth and eighteenth centuries, and Benin art "flourished from the sixteenth to the seventeenth century" (Roland Oliver and J. D. Fage, *A Short History of Africa* [Baltimore: Penguin Books, 1962], pp. 122–123; *EWA,* III, 380). "In fact, historical evidence supports the proposition that . . . declines in civilization have accompanied falls in abundance per capita" (Shepard B. Clough, *Basic Values of Western Civilization* [New York: Columbia University Press, 1960], p. 55). This has been partly owing to the out-migration of artists from the cities and states that have lost their "political and economic ascendancy" (Thomas Munro, *Evolution in the Arts and Other Theories of Culture History* [Cleveland: Cleveland Museum of Art, 1963], p. 520).

7. Verrier Elwin, *The Tribal Art of Middle India: A Personal Record* (London: Oxford University Press, 1951), p. 2.

8. Hans-Georg Bandi, Henri Breuil, Lilo Berger-Kirchner, Henri Lhote, Erik Holm, and Andreas Lommel, *The Art of the Stone Age* (New York: Crown, 1961).

9. Alfred Buehler, Terry Barrow, and Charles P. Mountford, *The Art of the South Sea Islands* (New York: Crown, 1962), p. 48.

10. Robert Redfield, *The Primitive World and Its Transformations* (Ithaca, N.Y.: Great Seal Books, 1958), p. 18.

11. There is, however, a tendency in nomadic cultures which lack both permanent settlements and stable centers of religious activity to develop extensive ceremonial as a functional equivalent of more objectified kinds of art.

12. Margaret Mead, *Sex and Temperament in Three Primitive Societies* (New York: New American Library, 1950), pp. 168–170; Leopold Pospisil, *The Kapauku Papuans of West New Guinea* (New York: Holt, Rinehart & Winston, 1963), pp. 15, 18–31.

13. Frederick J. Dockstader, *Indian Art in America* (Greenwich, Conn.: New York Graphic Society, 1962), p. 40.

14. Thorstein Veblen, *The Story of the Leisure Class* (New York: Modern Library, 1931), pp. 36–37, 45, 74–75.

15. Gimpel, pp. 38–42, 178.

16. In 1831, Tocqueville still held "the general mediocrity of fortunes, the absence of superfluous wealth . . . and the constant effort by which everyone attempts to procure [comfort]" responsible for the low level of the arts in the "democratic nations," exemplified by the United States of his day (Alexis de Tocqueville, *Democracy in America* [New York: Vintage Books, 1957], II, 50).

17. Adolph Siegfried Tomars, *Introduction to the Sociology of Art* (Mexico City, privately printed, 1940), p. 171.

18. Hauser, II, 20–23, 26–27, 29.

19. *Ibid.*, pp. 84–88.

20. René Grousset, *Chinese Art and Culture* (New York: Grove Press, 1959), p. 43.

21. *Ibid.*, p. 103.

22. In the long run, satisfaction with low economic attainment is likely to be reduced when direct comparisons with more economically productive cultures are possible. This may be implicit in V. Elwin's observation that "the explanation for [the] relative poverty of artistic inspiration" in the tribal cultures of central India "lies partly in the general depressed state of the populations that for centuries have been subjected to political and economic pressures from economically more advanced peoples" (*EWA*, I, 840).

23. Sorokin, *Society, Culture, and Personality*, p. 544.

24. W. W. Rostow, *The Stages of Economic Growth: A Non-Communist Manifesto* (Cambridge, Eng.: University Press, 1962), p. 38.

25. Eugen Weber, "The Secret World of Jean Barois: Notes

on the Portrait of an Age," in John Weiss, ed., *The Origins of Modern Consciousness* (Detroit: Wayne State University Press, 1965), p. 102. The economic slump of this period discouraged "some of the potentially active from turning to affairs from which little profit was to be expected. The most dynamic among the young discovered that advancement lay in non-economic enterprises of a political or cultural nature" (p. 103).

26. Camilla Gray, *The Great Experiment: Russian Art, 1863–1922* (New York: Abrams, 1962).

27. For a discussion of the effects of political cycles on artistic creativity, see Chapter 3.

28. Rostow, p. 40.

29. On such effects in Oceania and New Zealand, see Buehler *et al.*, pp. 51, 191. "Each of the epoch-making inventions which has caused an 'industrial revolution,' has caused an immediate decline in the artistic level of the pre-existing crafts" (Sir Hubert Llewellyn Smith, *The Economic Laws of Art Production: An Essay towards the Construction of a Missing Chapter of Economics* [London: Oxford University Press, 1924], pp. 146–147).

30. Bandi *et al.*, p. 69.

31. The data are derived from David C. McClelland, *The Achieving Society* (Princeton, N.J.: Van Nostrand, 1961), pp. 120, 132, 139.

32. The data are derived from Sorokin, *Social and Cultural Dynamics*, II, 148, 150. The data suggest that changes in the rate of inventions are associated with the level of foreign trade.

33. The data for Holland fail to reveal a clear pattern for the period from 1551 to 1675.

34. Sorokin, *Society, Culture, and Personality*, pp. 549–551.

35. The current tendency is to extend the Italian peak to

1680. The Italian efflorescence represents a movement of artistic centers from Tuscany to Rome to northern Italy and back to Rome.

36. There was, in addition, a flowering of manuscript illumination in twelfth-century England, which Sorokin disregards.

37. The English case is complicated by the fact that the period of economic integration after *commercial* expansion merged into the disturbance-of-equilibrium-phase of the *industrial* cycle. There seems to have been no distinguishable phase of economic latency, in which artistic creativity might have declined, between the two periods.

38. McClelland, p. 150.

39. Leo Lowenthal, *Literature, Popular Culture, and Society* (Englewood Cliffs, N.J.: Prentice-Hall, 1961), pp. 109–140.

40. William H. Whyte, Jr., *The Organization Man* (New York: Simon & Schuster, 1956).

41. R. Joseph Monsen, Jr., *Modern American Capitalism: Ideologies and Issues* (Boston: Houghton Mifflin, 1963), p. 26.

42. John Kenneth Galbraith, *The Affluent Society* (Boston, Houghton Mifflin, 1958).

43. Bandi *et al.*, p. 12.

44. Georges Bataille, *Lascaux; or, the Birth of Art: Prehistoric Painting* (Lausanne: Skira, 1955), pp. 20, 23.

45. Bandi *et al.*, p. 26.

46. See Emmanuel Anati, *Camonica Valley* (New York: Knopf, 1961), pp. 76–77, on northern Italian rock engravings; Bandi *et al.*, p. 90, on eastern Spanish, and p. 127, on Saharan rock carvings.

47. Rostow has visualized the danger of "secular spiritual stagnation—or boredom" in the stage of the industrialization process which he calls "beyond mass consumption." "This

stage has not yet been fully attained; but it has been attained by enough of the American and Northern European population to pose, as a serious and meaningful problem, the nature of the next stage" (pp. 91–92).

48. Gino Luzzatto, *An Economic History of Italy from the Fall of the Roman Empire to the Beginning of the Sixteenth Century* (New York: Barnes & Noble, 1961), pp. 142–146.

49. Francis Haskell, *Patrons and Painters: A Study in the Relations between Italian Art and Society in the Age of the Baroque* (New York: Knopf, 1963), p. 149.

50. If, however, such resources are committed to collecting historic works of art rather than supporting living artists, the creativity-stimulating effects of the integrative phase are likely to be slight.

3. Political-Action Cycles

1. Radhakamal Mukerjee, *The Social Functions of Art* (Bombay: Hind Kittabs, 1951), pp. 27–28.

2. Pitirim A. Sorokin, *Social and Cultural Dynamics*, III (New York: American Book Company, 1937), 365.

3. This is implicit in Sorokin's earlier observation that a "correlation between the war periods and the extraordinary number of the great men of genius born in such a period, or immediately after it, seems to exist" (Pitirim Sorokin, *Contemporary Sociological Theories* [New York: Harper, 1928], p. 351).

4. Adriaan J. Barnouw, *The Pageant of Netherlands History* (New York: Longmans, Green, 1952), p. 263.

5. During the Thirty Years' War, "the fine arts [also] flourished in Holland." But the Netherlands were less involved in this war than in their own struggle for independence.

Furthermore, the devastation of Germany gave a relative advantage, in this period, to the Netherlands (George Edmundson, *History of Holland* [Cambridge, Eng.: University Press, 1922], pp. 186, 199, 201).

6. A. L. Kroeber, *Configurations of Culture Growth* (Berkeley: University of California Press, 1944), p. 368.

7. *EWA*, V, 436.

8. *EWA*, II, 105; IV, 669.

9. Kroeber, p. 245.

10. See André Malraux, *The Metamorphosis of the Gods* (Garden City, N.Y.: Doubleday, 1960), p. 266.

11. Kroeber, pp. 700, 702, 709.

12. See René Grousset, *Chinese Art and Culture* (New York: Grove Press, 1959), pp. 117, 169; and André Grabar and Carl Nordenfalk, *Romanesque Painting from the Eleventh to the Thirteenth Century* (New York: Skira, 1958), pp. 113, 141.

13. *EWA*, I, 871; Kroeber, p. 689; *EWA*, I, 886–887; Herbert Read, *The Meaning of Art* (Baltimore: Penguin Books, 1961), p. 81; *EWA*, I, 231.

14. *EWA*, IV, 653; Kroeber, p. 694; *EWA*, II, 105; III, 331; V, 526; Richard Ettinghausen, *Arab Painting* (Lausanne: Skira, 1962), p. 142; *EWA*, II, 812, 819.

15. *EWA*, XIII, 149.

16. Maurice Serullaz, *French Painting: The Impressionist Painters* (New York: Universe Books, 1960), p. 55.

17. Camilla Gray, *The Great Experiment: Russian Art, 1863–1922* (New York: Abrams, 1962), p. 61.

18. Kroeber, p. 702.

19. Adolph Siegfried Tomars, *Introduction to the Sociology of Art* (Mexico City: privately printed, 1940), p. 376.

20. Grousset, pp. 35–37.

21. Sorokin, *Social and Cultural Dynamics*, III, 293, 295, 301, 319, 328, 331. For estimates of peaks of artistic creativity,

see Pitirim A. Sorokin, *Society, Culture, and Personality: Their Structure and Dynamics* (New York: Harper, 1947), pp. 549–550. The estimates of artistic peaks for Spain and Holland are my own, since Sorokin does not present any.

22. Chester G. Starr, *Civilization and the Caesars: The Intellectual Revolution in the Roman Empire* (New York: Norton, 1965), p. 238.

23. *Ibid.*, pp. 236, 238; Gino Luzzatto, *An Economic History of Italy from the Fall of the Roman Empire to the Beginning of the Sixteenth Century* (New York: Barnes & Noble, 1961), pp. 85, 142, 146, 143.

24. There was a slight increase in warfare during the 1700–1725 quarter-century, according to the estimated-casualties index.

25. Matthew Melko, "Peaceful Societies," unpublished manuscript, pp. 579–581; summarized in "Discovering Peace," *Peace Research,* 3 (Dec., 1971), 16–17, and "The Qualities of Peaceful Societies," *Peace Research,* 4 (Jan., 1972), 5–8. Melko's data on the Habsburg peace are based only on the Hungarian part of the empire.

26. Talcott Parsons and Robert F. Bales, "The Dimensions of Action Space," in Talcott Parsons, Robert F. Bales, and Edward A. Shils, *Working Papers in the Theory of Action* (Glencoe, Ill.: Free Press, 1953), p. 64.

27. Sorokin, *Social and Cultural Dynamics,* III, 293, 295, 301, 319, 328, 331; Peter C. Swann, *Chinese Painting* (New York: Universal Books, 1958), p. 18; Grousset, p. 170; Sorokin, *Society, Culture, and Personality,* p. 549; *EWA,* II, 802, 810, III, 331; Read, p. 82; Kroeber, p. 671; Rushton Coulborn, ed., *Feudalism in History* (Princeton, N.J.: Princeton University Press, 1956), pp. 372–373.

28. A. L. Kroeber, *A Roster of Civilizations and Culture* (Chicago: Aldine, 1962), p. 91.

29. Stuart Cary Welch and Milo Cleveland Beach, *Gods, Thrones and Peacocks; Northern Indian Painting from Two Traditions: Fifteenth to Nineteenth Centuries* (New York: Asia House Gallery, 1965), pp. 27–28.

30. Richard N. Frye, *Iran* (New York: Holt, 1953), pp. 55, 57; Grabar and Nordenfalk, pp. 113, 141.

31. Kroeber, *Configurations*, pp. 791–792.

32. George Kubler, *The Art and Architecture of Ancient America: The Mexican, Maya, and Andean Peoples* (Baltimore: Penguin Books, 1962), p. 21.

33. *Ibid.*, pp. 22, 272–273; J. Alden Mason, *The Ancient Civilizations of Peru* (Harmondsworth, Eng.: Penguin Books, 1957), p. 231.

34. Kubler, p. 22; G. C. Vaillant, *The Aztecs of Mexico* (Harmondsworth, Eng.: Penguin Books, 1956), p. 164.

35. Kubler, pp. 272–273, 322. "The Inca were empire builders, organizers, and engineers on a grand scale, rather than intellectuals, aesthetes, or bloodthirsty ritualists" (Julian H. Steward and Louis C. Faron, *Native Peoples of South America* [New York: McGraw-Hill, 1959], p. 13). The Aztec "empire" had a looser political structure, an indication of a less intensive commitment of social resources to goal-oriented action.

36. Since the phase-cycle theory focuses on the effects on artistic creativity of historical processes rather than of social structures, the differences in the organization of these societies and in their evolutionary level are not particularly relevant within the framework of the theory. A complete analysis in depth of *particular* historical situations would require the inclusion of statements about social organization not derivable from the present theory.

37. Roger Fry, *Last Lectures* (Boston: Beacon Press, 1962), p. 88.

38. "The art of the Inca period was . . . technically excellent, under perfect control, but uninspired and aesthetically the poorest of the several major traditions developed in Peru" (Mason, p. 231).

39. René Grousset, *The Rise and Splendour of the Chinese Empire* (Berkeley: University of California Press, 1953), p. 256.

40. Grousset, *Chinese Art and Culture*, pp. 291, 290.

41. Swann, p. 51.

42. Denise Paulme, *African Sculpture* (New York: Viking Press, 1962), p. 19.

43. Swann, p. 51. "The withdrawal of the ruling classes from politics, for whatever reason, also favors the development of a salvation religion"—hence, religious creativity (Max Weber, *The Sociology of Religion* [Boston: Beacon Press, 1964], p. 122).

44. Grousset, *Chinese Art and Culture*, p. 261.

45. James H. Billington, *The Icon and the Axe: An Interpretative History of Russian Culture* (New York: Knopf, 1966), p. 31.

46. Thomas Munro, *Evolution in the Arts and Other Theories of Culture History* (Cleveland: Cleveland Museum of Art, 1963), pp. 485–486. Munro suggests that a situation particularly propitious for creativity arises when "a small state, with simple administrative machinery, inherits the accumulated cultural wealth of larger, older nations" (p. 486).

47. Fry, p. 70.

48. Grousset, *Chinese Art and Culture*, p. 103.

49. S. de Madariaga, *Democracy versus Liberty?* (London: 1958), p. 17, cited in W. W. Rostow, *The Stages of Economic Growth: A Non-Communist Manifesto* (Cambridge, Eng.: University Press, 1962), p. 92.

4. Ideological-Action Cycles

1. Ruth Benedict, *Patterns of Culture* (New York: New American Library of World Literature, 1957), p. 34; Radhakamal Mukerjee, *The Social Functions of Art* (Bombay: Hind Kittabs, 1951), p. 20.

2. Erna Gunther, "Art in the Life of Primitive Peoples," in James A. Clifton, ed., *Introduction to Cultural Anthropology* (Boston: Houghton Mifflin, 1968), p. 91.

3. Arnold Hauser, *The Social History of Art* (New York: Vintage Books, 1957), I, 77.

4. *EWA*, IV, 264; XIV, 58.

5. Norman Cohn, *The Pursuit of the Millennium* (Fairlawn, N.J.: Essential Books, 1957).

6. Frederick Antal, *Florentine Painting and Its Social Background. The Bourgeois Republic before Cosimo de' Medici's Advent to Power: XIV and XV Centuries* (London: Kegan Paul, 1947), pp. 91, 66.

7. H. R. Trevor-Roper, "Four Faces of Heresy," *Horizon*, 6 (Spring, 1964), 16.

8. Heinrich Zimmer, *The Art of Indian Asia* (New York: Pantheon Books, 1955), I, 231.

9. Pitirim A. Sorokin, *Society, Culture, and Personality: Their Structure and Dynamics* (New York: Harper, 1947), p. 548.

10. A. L. Kroeber, *Style and Civilization* (Ithaca, N.Y.: Cornell University Press, 1957), p. 41.

11. *EWA*, III, 796; Herbert Read, *The Meaning of Art* (Baltimore: Penguin Books, 1961), p. 81.

12. Rudolf and Margot Wittkower, *Born under Saturn. The Character and Conduct of Artists: A Documented His-*

tory from Antiquity to the French Revolution (New York: Random House, 1963), p. 30.

13. Herta Haselberger, "Methods of Studying Ethnological Art," *Current Anthropology,* 2 (1961), 352.

14. William Fagg, "On the Nature of African Art," in Colin Legum, ed., *Africa: A Handbook to the Continent* (New York: Praeger, 1962), p. 422.

15. Frederick J. Dockstader, *Indian Art in America* (Greenwich, Conn.: New York Graphic Society, 1962), pp. 28, 39.

16. *EWA,* XIII, 31.

17. "Most historians of the period would say that . . . in the wake of 1905 . . . Russia had now entered an era of growing social and political stability." The intelligentsia, "now largely freed from the obsession of radical politics, . . . was responsible for a new flowering in the cultural life" (Leopold H. Haimson, "The Parties and the State: The Evolution of Political Attitudes," in Cyril E. Black, ed., *The Transformation of Russian Society: Aspects of Social Change Since 1861* [Cambridge, Mass.: Harvard University Press, 1960], p. 137).

18. Camilla Gray, *The Great Experiment: Russian Art, 1863–1922* (New York: Abrams, 1962).

19. Eric Hoffer, *The True Believer: Thoughts on the Nature of Mass Movements* (New York: New American Library, 1948), p. 140.

20. Sorokin, p. 549.

21. A. L. Kroeber, *Configurations of Culture Growth* (Berkeley: University of California Press, 1944), p. 274.

22. Arthur F. Wright, *Buddhism in Chinese Culture* (New York: Atheneum, 1965), pp. 42–64.

23. Kroeber, *Configurations,* pp. 274, 276–277.

24. André Grabar, *The Golden Age of Justinian: From the Death of Theodosius to the Rise of Islam* (New York: Odyssey Press, 1967), p. 1.

25. *EWA*, I, 447; V, 526; XIII, 69.

26. André Grabar and Carl Nordenfalk, *Romanesque Painting from the Eleventh to the Thirteenth Century* (Geneva: Skira, 1958), p. 143; see also p. 144. The Franciscan reforms may have contributed to the emergence of the naturalistic strain in the Italian Renaissance (Hauser, I, 14). In spite of its original antiart orientation, Franciscanism would seem to have exerted an artistically stimulating influence in the long run.

27. R. Trevor Davies, *The Golden Century of Spain, 1501–1621* (New York: Harper Torchbooks, 1961), p. 10.

28. Hauser, I, 141.

29. Frederick Antal, *Hogarth and His Place in European Art* (New York: Basic Books, 1962), p. 7.

30. In France, the artistic efflorescence of 1620–1670 (Sorokin, p. 550) began twenty-five years, and ended seventy-five years, after the termination of religious civil wars.

31. It is not entirely clear whether this perception must occur in the creative elites or in the general population to affect artistic creativity.

32. Kroeber, *Configurations*, p. 274.

33. *EWA*, III, 511.

34. Sorokin, p. 549.

35. G. T. Garratt, ed., *The Legacy of India* (Oxford: Clarendon Press, 1937), p. 84.

36. Max Weber, *The Sociology of Religion* (Boston: Beacon Press, 1964), p. 201.

37. Sorokin, p. 548. On relationships between emotionality and creativity, see Chapter 8.

38. Kroeber, *Configurations*, p. 684.

39. Alfred Buehler, Terry Barrow, and Charles P. Mountford, *The Art of the South Sea Islands* (New York: Crown, 1962), p. 175.

40. Wallace has speculated that movements of sociocultural

revitalization may occur "every ten or fifteen years" in "small tribal societies, in chronically extreme situations," but "in stable complex cultures, the rate of a society-wide movement may be one every two or three hundred years" (Anthony F. C. Wallace, *Culture and Personality* [New York: Random House, 1961], p. 155).

5. *Communal-Action Cycles*

1. Mehmat Beqiraj, *Peasantry in Revolution* (Ithaca, N.Y.: Cornell University, Center for International Studies, 1966), p. 3.

2. Emile Durkheim, *Suicide: A Study in Sociology* (New York: Free Press of Glencoe, 1963), p. 208; William J. Goode, "Illegitimacy, Anomie, and Cultural Penetration," *American Sociological Review*, 26 (1961), 910–925.

3. Pitirim A. Sorokin, *Social and Cultural Dynamics* (New York: American Book Company, 1937), III, 412, 418, 422, 428, 434, 440, 447, 455, 459.

4. The basis for identifying this period with the goal-attainment phase is the assumption that a sharp increase in domestic disorders indicates an intensive effort at reorganizing the institutions of the community.

5. Pitirim A. Sorokin, *Society, Culture, and Personality: Their Structure and Dynamics* (New York: Harper, 1947), pp. 549–551; on Byzantium, see André Grabar, *The Golden Age of Justinian: From the Death of Theodosius to the Rise of Islam* (New York: Odyssey Press, 1967), pp. 1, 337. Estimates for Spain and Holland are my own; and, in parentheses, I have presumed to correct Sorokin in three cases.

6. Whenever a peak terminates between two phases, its ending is assigned to the later phase.

7. In Spain, 1500–1800 is defined as a latency phase ac-

cording to the internal-disorders index. But the earlier part of this period could also be regarded as the phase of political integration of the Spanish nation after the final unification of Spain between 1469 and 1492. Thus, so far as effects on artistic creativity are concerned, an unfavorable phase may be offset by a favorable phase of a *different type* of cycle. Creativity declined after 1660, in a period which constitutes a latency phase in both the communal and political phase cycles. See Chapter 3.

8. J. S. Lee, "The Periodic Recurrence of Internecine Wars in China," *China Quarterly*, 14 (1931), 111–115, 159–163; excerpted in John Meskill, ed., *The Pattern of Chinese History: Cycles, Development, or Stagnation?* (Boston: Heath, 1965), p. 29.

9. Sorokin, *Society, Culture, and Personality*, p. 549.

10. *EWA*, III, 519.

11. René Grousset, *Chinese Art and Culture* (New York: Grove Press, 1959), pp. 117, 169, 132.

12. *EWA*, V, 100.

13. Sorokin, *Society, Culture, and Personality*, p. 550.

14. André Grabar and Carl Nordenfalk, *Romanesque Painting from the Eleventh to the Thirteenth Century* (Geneva: Skira, 1958), pp. 133, 141.

15. The decline in the U.S. suicide rate from 1933 to 1957 suggests a trend toward community integration (Louis I. Dublin, *Suicide: A Sociological and Statistical Study* [New York: Ronald Press Company, 1963], p. 210). This trend presumably includes the increasing incorporation of the ethnic groups into the overall social system. In this period the most important American contribution to visual art, abstract expressionism, was developed. Immigrants and the children of immigrants were prominent among its originators.

16. *EWA*, V, 107.

17. Gino Luzzatto, *An Economic History of Italy from the Fall of the Roman Empire to the Beginning of the Sixteenth Century* (New York: Barnes & Noble, 1961), pp. 66, 82, 83.

18. According to the internal-disorders index, which may represent the dynamics of the "national community," 1300–1400 was a goal-attainment period in Italy. It is not illogical to expect that, after having achieved internal consolidation, the new urban communities would intensify their struggle for national dominance.

19. Lloyd Goodrich and John I. H. Baur, *American Art of Our Century* (New York: Praeger, 1961), p. 9.

20. Helen Gardner, *Art Through the Ages* (3d ed.; New York: Harcourt, Brace, 1948), p. 697.

21. Alfredo Colombo and Gaston Diehl, *A Treasury of World Painting* (Tudor, n.d.), pp. 85–86.

22. Camilla Gray, *The Great Experiment: Russian Art, 1863–1922* (New York: Abrams, 1962).

23. In this sense, the New Deal may have been one of the preconditions for the efflorescence of American painting after World War II.

24. Arnold Hauser, *The Social History of Art* (New York: Vintage Books, 1957), III, 16.

25. Eric Hoffer, *The True Believer: Thoughts on the Nature of Mass Movements* (New York: New American Library, 1958), pp. 139–140.

26. A survey of feudal reorganization has concluded that "a general cultural revival cannot occur until revival has decisively started in the crucial material-political sphere" (Rushton Coulborn, ed., *Feudalism in History* [Princeton, N.J.: Princeton University Press, 1965], p. 372).

27. A similar situation has developed in Oceania (Alfred Buehler, Terry Barrow, Charles P. Mountford, *The Art of the South Sea Islands* [New York: Crown, 1962], p. 51).

28. *EWA*, II, 217.

29. Frederick J. Dockstader, *Indian Art in America* (Greenwich, Conn.: New York Graphic Society, 1962), p. 30.

30. Paul S. Wingert, *The Sculpture of Negro Africa* (New York: Columbia University Press, 1950), p. 8.

31. Erna Gunther, "Art in the Life of Primitive Peoples," in James A. Clifton, ed., *Introduction to Cultural Anthropology* (Boston: Houghton Mifflin, 1968), p. 82.

32. Hans Himmelheber, "The Present Status of Sculptural Art among the Tribes of the Ivory Coast," in June Helm, ed., *Essays on the Verbal and Visual Arts* (Seattle: American Ethnological Society, 1967), p. 196.

33. Pitirim A. Sorokin, *Man and Society in Calamity: The Effects of War, Revolution, Famine, Pestilence upon Human Mind, Behavior, Social Organization, and Cultural Life* (New York: Dutton, 1942), pp. 256, 160.

34. Sorokin, *Society, Culture, and Personality*, pp. 541–542; *Man and Society*, p. 258. Sorokin's "law of polarization" is a descriptive characterization rather than an explanatory mechanism.

35. Amaury de Riencourt, *The Soul of China* (New York: Coward McCann, 1958), p. 94.

36. Don Martindale, *Social Life and Cultural Change* (Princeton, N.J.: Van Nostrand, 1962), p. 505.

37. "The Chinese family ties were weak during the Ch'in and former Han period (221 B.C.–A.D. 8). Being apprehensive of the possible correlation between weak family ties and social instability, the rulers of former and later Han repeatedly exhorted the nation to practice the Confucian teaching of filial duty" (Ping-ti Ho, "An Historian's View of the Chinese Family System," in Seymour M. Farber, Piero Mustacchio, and Roger H. L. Wilson, eds., *Man and Civilization: The Family's Search for Survival* [New York: McGraw-Hill, 1963), p. 19).

38. The need for other kinds of cultural products—religion, philosophy, science, and myth—may also be increased by a high salience of integrative exigencies in the community system (Martindale, p. 91; Sorokin, *Society, Culture, and Personality*, p. 541; Lewis S. Feuer, *The Scientific Intellectual: The Psychological & Sociological Origins of Modern Science* [New York: Basic Books, 1963], pp. 275–276; Bronislaw Malinowski, *Magic, Science, and Religion, and Other Essays* [Garden City, N.Y.: Doubleday Anchor, 1954], p. 126). Conversely, communal latency may reduce even technological inventiveness (William N. McNeill, *The Rise of the West: A History of the Human Community* [Chicago: University of Chicago Press, 1963], pp. 40–41). Thus the present theory, at its most abstract, may apply to cultural creativity in general. But the specific direction of creativity depends on the value system of the society and the accumulation of technical prerequisites for a specific type of creative action. These variables are not directly dependent on the cyclical movement of community integration.

6. Achievement-Motivation Cycles

1. See Chapter 2.
2. David C. McClelland, *The Achieving Society* (Princeton, N.J.: Van Nostrand, 1961), pp. 119, 125.
3. Evan Davies, "This Is the Way Crete Went—Not with a Bang but with a Simper," *Psychology Today*, 3 (Nov., 1969), 46.
4. McClelland, pp. 131, 150.
5. *Ibid.*, pp. 139, 145–149.
6. A cross-cultural study has revealed a negative correlation between McClelland's "need-achievement index" and "standard of living data" in contemporary nations (Betty A. Nes-

vold, "Scalogram Analysis of Political Violence," *Comparative Political Studies,* 2 [July, 1969], 191).

7. Herbert Barry III, Irvin L. Child, and Margaret K. Bacon, "Relation of Child Training to Subsistence Economy," *American Anthropologist,* 61 (Feb., 1959), 57.

8. Sorokin has observed that luxury tends to reduce artistic creativity. See Chapter 2.

9. Gino Luzzatto, *An Economic History of Italy from the Fall of the Roman Empire to the Beginning of the Sixteenth Century* (New York: Barnes & Noble, 1961), pp. 85, 142, 146, 143.

10. Vytautas Kavolis, "A Role Theory of Artistic Interest," *Journal of Social Psychology,* 60 (June, 1963), 31–37.

11. Miguel Prados, "Rorschach Studies on Artists and Painters," *Rorschach Research Exchange,* 8 (Oct., 1944), 183.

12. Ravenna Helson, "Personality of Women with Imaginative-Artistic Interests: The Role of Masculinity, Originality, and Other Characteristics in Their Creativity," *Journal of Personality,* 34 (March, 1966), 1–25.

13. "The reason may be that too high nAchievement leads to considerable frustration . . . because positive results are not obtained often enough and with sufficient regularity to please the person with high nAchievement, whereas very low nAchievement may simply lead to laziness" (David McClelland, "On the Psychodynamics of Creative Physical Scientists," in Howard E. Gruber, Glenn Terrell, and Michael Wertheimer, eds., *Contemporary Approaches to Creative Thinking: A Symposium Held at the University of Colorado* [New York: Atherton Press, 1964], p. 147).

14. S. G. Lee, "Social Influences in Zulu Dreaming," *Journal of Social Psychology,* 47 (1958), 265–283.

15. Irvin L. Child, "Personal Preferences as an Expression of Aesthetic Sensitivity," *Journal of Personality,* 30 (Sept., 1962), 507; "Personality Correlates of Esthetic Judgment in

College Students," *Journal of Personality,* 33 (Sept., 1965), p. 497.

16. "As for our own [Nero's] times, why, we are so besotted with drink, so steeped in debauchery, that we lack the strength even to study the great achievements of the past" (*The Satyricon of Petronius,* trans. William Arrowsmith [Ann Arbor: University of Michigan Press, 1959], p. 90).

17. McClelland, p. 120.

18. Anthony F. C. Wallace, *Religion: An Anthropological View* (New York: Random House, 1966).

19. Hans Himmelheber, *Eskimokünstler: Ergebnisse einer Reise in Alaska* (2d ed.; Kassel: Heinrich-Röth, 1953), pp. 17–19.

20. C. Daryll Forde, *Habitat, Economy, and Society: A Geographical Introduction to Ethnology* (New York: Dutton, 1963), p. 100.

21. Himmelheber, p. 85.

22. A. Alvarez, *Under Pressure. The Writer in Society: Eastern Europe and the U.S.A.* (Baltimore: Penguin Books, 1965), p. 182; James R. Mellow, "Where It's Happening," *New York Times,* Oct. 22, 1967, Section D, p. 24.

7. Culture-Mentality Cycles

1. John Ruskin, cited in Pitirim A. Sorokin, *Social and Cultural Dynamics* (New York: American Book Company, 1937), I, 313; Frank P. Chambers, *Cycles of Taste: An Unacknowledged Problem in Ancient Art and Criticism* (Cambridge, Mass.: Harvard University Press, 1928), p. 119; Kenneth Clark, "The Blot and the Diagram," *Encounter,* 20 (Jan., 1963), p. 36; Radhakamal Mukerjee, *The Social Functions of Art* (Bombay: Hind Kittabs, 1951), pp. 19, 22.

2. Sorokin, I, 378–382, 389–393, 411–415. For estimates of peaks of artistic creativity, see Pitirim A. Sorokin, *Society, Culture, and Personality: Their Structure and Dynamics* (New York: Harper, 1947), pp. 549–551. Sorokin separates, from before the tenth to the eighteenth century, "Christian art" from the national series. This separation is probably inavoidable because of the internationalism of the Catholic Church, but it may distort the basis on which national fluctuations in culture mentality have been computed.

3. In this dating, Sorokin is following the nineteenth-century convention. Recent works of art history date the beginning of the decline of Italian art with the death of Bernini in 1680, thus including the high baroque as well as the High Renaissance in the presently accepted conception of the Italian artistic efflorescence. See John Rupert Martin, *The Farnese Gallery* (Princeton, N.J.: Princeton University Press, 1965).

4. Sorokin, *Social and Cultural Dynamics,* I, 400.

5. Vytautas Kavolis, *Artistic Expression—A Sociological Analysis* (Ithaca, N.Y.: Cornell University Press, 1968), p. 199.

6. Ideational latency is suggested from the seventh to the middle of the sixth century B.C., a disturbance of latency about 550, Idealistic goal attainment and integration during the fifth and fourth centuries, and Sensate latency from the third century on (Sorokin, *Social and Cultural Dynamics,* pp. 285–286). Sorokin's estimate of the peak of Greek artistic creativity is 559–300 B.C.

7. A. L. Kroeber, *Configurations of Culture Growth* (Berkeley: University of California Press, 1944), pp. 802–803.

8. Hugo Munsterberg, *The Arts of Japan: An Illustrated History* (Rutland, Vt.: Tuttle, 1962), pp. 51, 43.

9. In this chapter, such periods have been dealt with as relatively brief historical phases. It is, however, conceivable

that in less rapidly changing cultures a state of "balanced tension" may become relatively permanent, and that it may be one factor that distinguishes artistically creative from relatively uncreative societies.

10. "The Great Age of Greek Enlightenment was also, like our own time, an Age of Persecution. . . . About 432 B.C. or a year later, disbelief in the supernatural and the teaching of astronomy were made indictable offenses. The next thirty odd years witnessed a series of heresy trials which is unique in Athenian history. The victims included most of the leaders of progressive thought at Athens" (E. R. Dodds, *The Greeks and the Irrational* [Boston: Beacon Press, 1957], p. 189).

11. Jane Ellen Harrison, *Ancient Art and Ritual* (London: Oxford University Press, 1951), p. 136.

12. Herbert Marcuse, *Eros and Civilization: A Philosophical Inquiry into Freud* (New York: Vintage Books, 1962), pp. 157–158.

8. Sex Norms, Emotionality, and Artistic Creativity

1. Bernard Rosenberg and Norris Fliegel, *The Vanguard Artist: Portrait and Self-Portrait* (Chicago: Quadrangle Books, 1965), pp. 333, 343.

2. G. Rattray Taylor, writing in the psychoanalytic vein, has suggested that "artistic productivity reaches a maximum at a point midway between [restrictiveness and permissiveness]—as it did in the Elizabethan Age. Under extreme [restrictiveness], spontaneity is too strongly repressed; under extreme [permissiveness], there may be insufficient discipline to school and direct the creative urge" (*Sex in History* [New York: Vanguard, 1954], p. 286).

3. Rosenberg and Fliegel, p. 337.

4. Frank Barron, "The Psychology of Creativity," *New Directions in Psychology*, II (New York: Holt, Rinehart & Winston, 1965), pp. 40, 99.

5. Robert O. Blood, Jr., "Romance and Premarital Intercourse—Incompatibles?" *Marriage and Family Living*, 14 (1952), 105–108; Robert W. Shirley and A. Kimball Romney, "Love Magic and Socialization Anxiety: A Cross-Cultural Study," *American Anthropologist*, 64 (1962), 1028–1031; William J. Stephens, *The Family in Cross-Cultural Perspective* (New York: Holt, Rinehart & Winston, 1963), pp. 206–207; Paul C. Rosenblatt, "A Cross-Cultural Study of Child Rearing and Romantic Love," *Journal of Personality and Social Psychology*, 4 (1966), 338.

6. Pitirim A. Sorokin, *Social and Cultural Dynamics* (New York: American Book Company, 1937), II, 31.

7. Wendy Doniger O'Flaherty, "Asceticism and Sexuality in the Mythology of Śiva, Part I," *History of Religion*, 8 (1969), 300–337.

8. William Goode, "The Theoretical Importance of Love," *American Sociological Review*, 24 (1959), 38–47.

9. Max Weber, *The Sociology of Religion* (Boston: Beacon Press, 1964), p. 236.

10. Sorokin, II, 29, 31.

11. *Ibid.*

12. William Edward Hartpole Lecky, *History of European Morals*, II (New York: Appleton, 1904), pp. 102–103.

13. Taylor, pp. 138, 192–193.

14. See Yehudi A. Cohen, " 'Adolescent Conflict' in a Jamaican Community," in Yehudi A. Cohen, ed., *Social Structure and Personality: A Casebook* (New York: Holt, Rinehart & Winston, 1962), p. 171; and Lee Rainwater, "Crucible of Identity: The Negro Lower Class Family," in

Gerald Handel, ed., *The Psycho-social Interior of the Family: A Sourcebook for the Study of Whole Families* (Chicago: Aldine, 1967), pp. 372–373.

15. Oscar Lewis, *La Vida: A Puerto Rican Family in the Culture of Poverty—San Juan and New York* (New York: Vintage Books, 1968).

16. Kenneth Cavander, "The Astarte Phenomenon," *Horizon*, 13 (Spring, 1971), 15–18, 27.

17. Lecky, pp. 101, 122.

18. Charles E. Winick, *The New People: Desexualization in American Life* (New York: Pegasus, 1968), p. 308. The relationship between asceticism and sexual desire is impressively elaborated in Hindu mythology (O'Flaherty, *op. cit.*).

19. Lecky, p. 153.

20. André Grabar, *The Golden Age of Justinian: From the Death of Theodosius to the Rise of Islam* (New York: Odyssey Press, 1967), p. 1.

21. "The ablest men in the Christian community vied with one another in inculcating as the highest form of duty the abandonment of social ties and the mortification of domestic affections." The abandonment of wife and child "to the mercies of the world, was regarded by the true hermit as the most acceptable offering he could make to his God" (Lecky, pp. 131, 125).

22. This qualification is necessitated by the lack of historical records of actual behavior in accordance with the literary canon of courtly love (F. X. Newman, ed., *The Meaning of Courtly Love* [Albany, N.Y.: State University of New York Press, 1968]).

23. Herbert Moller, "The Social Causation of the Courtly Love Complex," in Werner J. Cahnman and Alvin Boskoff, eds., *Sociology and History: Theory and Research* (New York: Free Press of Glencoe, 1964), pp. 486, 487.

24. Herbert Moller, "The Social Causation of Affective Mysticism," *Journal of Social History*, 4 (1971), 305–338.

25. Lecky, pp. 332–333.

26. Denis de Rougemont, *Love in the Western World*, Rev. Ed. (New York: Pantheon Books, Inc., 1960), pp. 74–102.

27. For an argument that the continuous history of heretical movements which started in the twelfth century resulted from "the reforming, even revolutionary, fervor" of Pope Gregory VII, see R. I. Moore, "The Origins of Medieval Heresy," *History*, 55 (Feb., 1970), 21–36.

28. Taylor, p. 135. In European love poetry generally, "a major change of theme and form only occurs around the turn of the fourteenth century. . . . Whereas previously love represented the loftiest possible life for the knight, it now becomes almost an occupation for the young men who must sow their wild oats" (Matthias Walz, "Methodological Reflections Suggested by the Study of Groups of Limited Complexity: Outline of a Sociology of Medieval Love Poetry," *International Social Science Journal*, 19 [1967], p. 604).

29. No period in Christian Europe reached the extreme permissiveness represented, say, by the Kaingáng Indians. See Jules Henry, *Jungle People: A Kaingáng Tribe of the Highlands of Brazil* (New York: Vintage Books, 1964).

30. See Chapter 7.

31. Moller, "Affective Mysticism," p. 315. This development took place on the basis of a tradition of "mystical experience and expression" that had "developed throughout the Middle Ages" but remained more contemplative, less eroticized in character (R. Trevor Davies, *The Golden Century of Spain, 1501–1621* [New York: Harper Torchbooks, 1961], p. 290).

32. Moller, "Affective Mysticism," p. 317.

33. Davies, p. 290.

34. Moller, "Affective Mysticism," p. 322.

35. See Chapter 7.

36. Taylor, pp. 191, 195.

37. Morton M. Hunt, *The Natural History of Love* (New York: Minerva Press, 1967), p. 310. Periods of rationalism, as also in classical Greece, tend to be sexually permissive for males. But not all permissive periods or societies are rationalistic.

38. Peter T. Cominos, "Late-Victorian Sexual Respectability and the Social System," *International Review of Social History*, 8 (1963), pp. 225–227.

39. Taylor, p. 204.

40. Cominos, pp. 46–48, 248.

41. Walter E. Houghton, *The Victorian Frame of Mind, 1830–1870* (New Haven: Yale University Press, 1957), pp. 372–393.

42. Pitirim A. Sorokin, *Society, Culture, and Personality: Their Structure and Dynamics* (New York: Harper, 1947), p. 550.

43. Arnold Hauser, *The Social History of Art* (New York: Vintage Books, 1957), I, 219.

44. Alfred C. Kinsey, Wardell Pomeroy, and Clyde E. Martin, *Sexual Behavior in the Human Male* (Philadelphia: W. B. Saunders, 1948); Alfred C. Kinsey, Wardell Pomeroy, Clyde E. Martin, and Paul B. Gebhard, *Sexual Behavior in the Human Female* (Philadelphia: W. B. Saunders, 1953).

45. Winick, pp. 273, 330, 334; James T. Carey, "Changing Courtship Patterns in the Popular Song," *American Journal of Sociology*, 74 (1969), 728; Rollo May, "Love and Will," *Psychology Today*, 3 (Aug., 1969), 22.

46. "This is the philosophy behind much of the Tantric sexuality of the later Purāṇas: one may perform the *act* of sexual intercourse without losing one's purity, as long as the

mind remains uninvolved. . . . Physical involvement without emotional involvement makes him [Śiva] even a greater yogi than he would be if he merely remained forever in his meditation" (O'Flaherty, pp. 329, 334).

47. Lewis Yablonsky, *The Hippie Trip* (New York: Pegasus, 1968), p. 309.

48. Lucy R. Lippard, "Eros Presumptive," in Gregory Battcock, ed., *Minimal Art: A Critical Anthology* (New York: Dutton, 1968), p. 209.

49. Zevedei Barbu, *Problems of Historical Psychology* (New York: Grove Press, 1960), p. 60; Weber, pp. 48, 236; Jacques Ellul, *The Technological Society* (New York: Knopf, 1965), p. 421; George Rosen, *Madness in Society: Chapters in the Historical Sociology of Mental Illness* (Chicago: University of Chicago Press, 1968), chap. vii. The variables cited in these works, such as authoritarianism, rationalization of coercion, acceleration of change, and social stress, seem mainly to promote a violent and labile kind of emotionality that is expressive of social strain instead of promoting the investment of affection in particular social relations. Intermediate sex norms appear more likely to have the latter effect, especially on social relations between the sexes.

50. Willystone Goodsell, *A History of the Family as a Social and Educational Institution* (New York: Macmillan, 1915), pp. 136–138.

51. Winick, *op. cit.*, pp. 343–344.

52. David L. McClelland, *The Achieving Society* (Princeton, N.J.: Van Nostrand, 1961), p. 123.

53. Thus "sex offenses," especially the seduction of nuns, "were usually severely punished" in Renaissance Italy, though less frequently after the fourteenth century (Marvin E. Wolfgang, "Socio-economic Factors Related to Crime and Punishment in Renaissance Florence" *Journal of Criminal Law, Criminology and Police Science*, 47 [1956], 322).

54. Stephens, p. 252; George Peter Murdock, *Social Structure* (New York: Free Press, 1965), p. 264; Clellan S. Ford and Frank A. Beach, *Patterns of Sexual Behavior* (New York: Ace Books, 1951), p. 121.

55. Norman O. Brown, *Life against Death: The Psychoanalytical Meaning of History* (New York: Random House, 1959), p. 63.

9. The Phase-Cycle Theory of Artistic Creativity

1. The distinction between two types of latency is suggested by Nikolai Danilevsky's differentiation between apathy of self-satisfaction and apathy of despair and by Toynbee's observation that the "nemesis of creativity" may be due either to contentment with economic and cultural achievements or to an exhaustion of energy in constant struggle for the unattainable (Pitirim A. Sorokin, *Social Philosophies of an Age of Crisis* [Boston: Beacon Press, 1951], pp. 65–66; Arnold J. Toynbee, *A Study of History*, IV [London: Oxford University Press, 1939], 245–584).

2. Vytautas Kavolis, "A Role Theory of Artistic Interest," *Journal of Social Psychology*, 60 (1963), 31–37.

3. In religious, philosophical, and scientific thought, "the creative epochs . . . are the periods of the formation of new communities," because, Martindale argues, the community that has broken down cannot effectively control the imagination of its intellectuals (Don Martindale, *Social Life and Cultural Change* [Princeton, N.J.: Van Nostrand, 1962], p. 91).

4. Technical resources, such as tools and a knowledge of materials, must also be available, and their increase may have an artistically stimulating effect. The availability of natural resources, such as wood or marble, also affects artistic crea-

tivity. The availability of natural resources tends to be constant in the same area over long periods and cannot by itself account for changes in the quality of art creation. The disappearance of such resources can, however, terminate artistic traditions, as a great drought in the thirteenth century brought to an end the classic age of Pueblo culture (*EWA*, I, 237).

5. A. L. Kroeber, *Configurations of Culture Growth* (Berkeley: University of California Press, 1963), p. 804.

6. Rudolf and Margot Wittkower, *Born under Saturn. The Character and Conduct of Artists: A Documented History from Antiquity to the French Revolution* (New York: Random House, 1963), p. 293; Thomas Munro, "The Psychology of Art: Past, Present, Future," *Journal of Aesthetics and Art Criticism*, 21 (1963), 277. Since the romantic period, while styles of artistic expression have become diversified, the artistic personality may have become more psychologically stereotyped. If a compression of artists into the "bohemian" mold has really occurred, it may have reduced artistic creativity by preventing "nonbohemian" personalities from being creative to the fullest extent of their capability.

7. Experimental research reveals that originality is associated with a "disposition toward integration of diverse stimuli" and "of feminine and masculine components" of the personality (Frank Barron, "The Psychology of Creativity," *New Directions in Psychology*, II [New York: Holt, Rinehart & Winston, 1965], 39, 99).

8. Yehudi A. Cohen, "Ends and Means in Political Control: State Organization and the Punishment of Adultery, Incest, and Violation of Celibacy," *American Anthropologist*, 71 (1969), 658–687.

9. See Chapter 8, note 49.

10. Max Weber, *The Protestant Ethic and the Spirit of Capitalism* (New York: Scribner's, 1958).

11. If the activities of the Spanish Inquisition are taken into account, the golden age of Spain may appear as one of communal-goal attainment—similar to the golden age of Greece.

12. See E. R. Dodds, *The Greeks and the Irrational* (Berkeley: University of California Press, 1964), pp. 244–253.

13. See Chapters 6 and 7.

14. See David C. McClelland, *The Achieving Society* (Princeton, N.J.: Van Nostrand, 1961), pp. 294–295.

15. Anthony F. C. Wallace, *Culture and Personality* (New York: Random House, 1961), pp. 143–156.

16. David and Vera Mace, *The Soviet Family* (Garden City, N.Y.: Doubleday, 1964), pp. 73–91.

17. Philip E. Slater, *The Glory of Hera: Greek Mythology and the Greek Family* (Boston: Beacon Press, 1968); Alvin W. Gouldner, *The Hellenic World: A Sociological Analysis* (New York: Harper & Row, 1969).

18. R. B. Cattell, H. Breul, and H. Parker Hartman, "An Attempt at More Refined Definition of the Cultural Dimensions of Syntality in Modern Nations," *American Sociological Review*, 17 (1952), 408–421.

19. Psychological tests of creative subjects suggest, however, the presence in them of "a good deal of psychic turbulence" or "evidence of psychopathology" and, at the same time, "adequate" or "superior" ego controls (Donald W. MacKinnon, "Creativity," *International Encyclopedia of the Social Sciences*, III [New York: Macmillan and Free Press, 1968], 438–439). At its historic origin, art creation may have been used for overcoming individual pathology in such a way that the collective identity of the group was strengthened in the process (Andreas Lommel, *Shamanism: The Beginnings of Art* [New York: McGraw-Hill, 1967], pp. 8–13, 76, 148).

10. Some Social Functions of Artistic Values

1. See also my "Art Content and Social Involvement," *Social Forces*, 42 (1964), 467–472.

2. "Beauty results from the reciprocal action of two opposed drives and from the uniting of two opposed principles" (Friedrich Schiller, *On the Aesthetic Education of Man*, tran. Elizabeth M. Wilkinson and L. A. Willoughby [Oxford: Clarendon Press, 1967], p. 112).

3. Erich Kahler, *The Disintegration of Form in the Arts* (New York: Braziller, 1968).

4. For a major development of this theme, see Robert P. Abelson, Elliot Aronson, William J. McGuire, Theodore M. Newcomb, Milton J. Rosenberg, and Percy H. Tannenbaum, eds., *Theories of Cognitive Consistency: A Sourcebook* (Chicago: Rand McNally, 1968).

5. John Cage, *A Year from Monday: New Lectures and Writings* (Middletown, Conn.: Wesleyan University Press, 1967).

6. Renato Poggioli, *The Theory of the Avant-garde* (Cambridge, Mass.: Harvard University Press, 1968), p. 137.

7. Morse Peckham, *Man's Rage for Chaos: Biology, Behavior, and the Arts* (New York: Schocken Books, 1967); Cage, *op. cit.*

8. For further development of these ideas, see Vytautas Kavolis, "The Possibilities of an American Artistic Efflorescence," *Journal of Aesthetic Education*, 4 (Oct., 1970), 21–36.

9. The following two paragraphs are adopted from my "On the Crisis of Creativity in Contemporary Art," *Arts in Society*, 7 (1970), 207.

10. James S. Ackerman, "The Demise of the Avant-Garde:

Notes on the Sociology of Recent American Art," *Comparative Studies in Society and History,* 11 (1969), 371–384.

11. Speculations on the Excellence of Forms

1. Max Raphael, *The Demands of Art* (Princeton, N.J.: Princeton University Press, 1968), pp. 193–194.

2. Vytautas Kavolis, "Post-modern Man: Psychocultural Responses to Social Trends," *Social Problems,* 17 (1970), 435–448.

3. Vytautas Kavolis, *Artistic Expression—A Sociological Analysis* (Ithaca, N.Y.: Cornell University Press, 1968), pp. 59, 140, 144, 165–172, 179.

4. This may be the point of the complaints that, in the 1960's, American "art had become too thoroughly integrated into the fabric of our culture—that, in other words, the tension that formerly existed between the best art and the mainstream of our cultural assumptions had become dangerously and rather smugly attenuated" (Hilton Kramer, "Art in 1967: Changing Context," *New York Times,* Dec. 31, 1967, Section D, p. 32).

5. Thomas B. Hess, "A Tale of Two Cities," in Gregory Battcock, ed., *The New Art: A Critical Anthology* (New York: Dutton, 1966), p. 169.

6. Renato Poggioli, *The Theory of the Avant-garde* (Cambridge, Mass.: Harvard University Press, 1968), p. 20. A consciously avant-garde artist tends to be a better prophet than creator, "because his mind is only partly on his work," on making objects of art (James S. Ackerman, "Art History and the Problems of Criticism," *Daedalus,* 89 [1960], p. 259).

7. Berlew has found that the orientation toward the future was strongest in Greece between 900 and 475 B.C., declined

between 475 and 362, and weakened still further between 362 and 100 B.C. (David C. McClelland, *The Achieving Society* [Princeton, N.J.: Van Nostrand, 1961], p. 123).

8. Doctrinal hardening of artistic programs may inhibit creativity, as may have happened in French impressionism after 1880 (Maurice Serullaz, *French Painting: The Impressionist Painters* [New York: Universe Books, 1960], p. 64).

9. Craftsmanship by itself is more highly regarded, in judging works of art, by "nonexperts" than by artists and art scholars (J. W. Getzels and M. Csikszentmihalyi, "Aesthetic Opinion: An Empirical Study," *Public Opinion Quarterly,* 33 [Spring, 1969], p. 41).

Index

HISTORY ON ART'S SIDE

Designed by R. E. Rosenbaum.
Composed by Vail-Ballou Press, Inc.,
in 11 point linotype Baskerville, 2 points leaded,
with display lines in 20th Century Medium and Bold.
Printed letterpress from type by Vail-Ballou Press
on Warren's No. 66 text, 60 pound basis,
with the Cornell University Press watermark.
Bound by Vail-Ballou Press
in Interlaken book cloth
and stamped in All Purpose foil.

Library of Congress Cataloging in Publication Data
(For library cataloging purposes only)

Kavolis, Vytautas Martynas, date.
　History on art's side.

　Includes bibliographical references.
　　1. Art and society.　2. Art—Psychology.
I. Title.
N72.S6K33　　　301.2　　　70-38683
ISBN 0-8014-0715-X